forgo TALES of FLORIDA

Bob Patterson

illustrations by
Kyle McQueen

THE
History
PRESS

Published by The History Press
Charleston, SC 29403
www.historypress.net

Copyright © 2009 by Bob Patterson
All rights reserved

First published 2009
Second printing 2009
Third printing 2012

Cover design by Natasha Momberger.

Manufactured in the United States

ISBN 978.1.59629.799.9

Library of Congress Cataloging-in-Publication Data

Patterson, Bob.
Forgotten tales of Florida / Bob Patterson.
p. cm.
ISBN 978-1-59629-799-9
1. Florida--History--Anecdotes. 2. Florida--Social life and customs--
Anecdotes. 3. Folklore--Florida--Anecdotes. I. Title.
F311.6.P38 2009
398.209759--dc22
2009035284

Foreword

Bob Patterson is an extraordinary man. He seems to never bury a talent, but in time develops each one to strengthen those he has already nurtured into well-being: photography, music, storytelling, writing and more.

It is my understanding that he spent quality time camping, canoeing and fishing with the talented musician Will McLean and highly talented wordsmith Gamble Rogers. They were his mentors as he perfected his ability to evoke chills, laughter and tears.

Bob's latest feat, *Forgotten Tales of Florida*, is a delectable collection of folk tales and personal stories all dressed up in a designer's attire. The saga of William Ellis is sheer delight from beginning to end.

Every cache of Florida stories will be sadly incomplete without a copy of this book.

Annette J. Bruce
Author/storyteller
Co-founder Florida Storytelling Association

Preface

L et me begin by telling you that I am not originally from Florida. As a matter of fact, I'm from up north. When you say that to folks around Florida, you're going to get many different responses. I met an old "Conch" once down in Key West and asked him, "Hey man, do you ever get up north?" He looked me straight in the eye and said, "Yep, yep, I git up to Miami about twice'd a year." But I did grow up in wilderness. I practically had to pack a lunch just to go to the mailbox. I grew up alongside a river, a river that got so low at times that you could walk across it in places. In other times, the floodwaters would come crashing up against our house, and I was always amazed at how my daddy insisted on carrying everyone in the family out through the floodwaters. There was Mom, my two sisters and myself. Sometimes the water would be right up to his chin. We all thought that was just incredible, because my

father was the only one in the family who didn't know how to swim.

I learned how to hunt, fish and trap alongside that river. You know, Henry David Thoreau said that we all ought to learn how to do that because of the lessons that they teach you about wild things and wild places. He said that if we really learned those lessons well, we'd quit. And it's no surprise that as a young man growing up in the 1940s, one of my childhood heroes was Tarzan. We've all seen those Tarzan movies and know that the storyline takes place in Africa. But the truth of the matter is that most of those movies were made right here in Florida. So when I moved to Florida some forty years ago, my first impression was that I had moved to Africa. I thought, "Wow! This is a wild place!"

Over the years, I've learned the importance of wild places to the human condition. Everybody has their favorite wild place. For you, it might be your own backyard, the empty lot across the street or the woods down at the end of the road. This book is about my favorite wild place: Florida. It was created from a lifetime of personal experiences and encounters with Florida's folklore, history, people and culture. I hope you're entertained by the stories, and I hope that you will join me in helping to protect this wondrous place we know as Florida for generations to come.

I've always told little stories as introductions to songs during my career as a singer/songwriter. It wasn't until I began working with Gamble Rogers that I started to

understand the power of storytelling. It was during this same period of time that I befriended Florida's Black Hat Troubadour, Will McLean, who suggested that I direct my writing and music skills toward saving Florida's environment. I am grateful for having known these fine human beings. I am grateful, too, for knowing Annette Bruce, who introduced me to the Florida storytelling community and who has been so helpful with my storytelling adventures. I want to thank those dear friends who read the manuscript, offering good suggestions and checking for typographical errors. Mostly, I am grateful to Erin Wiedemer (www.awriteword.com), who not only edited the manuscript, but also was a constant source of guidance for this writing project.

Forgotten Tales of Florida

OLD TEN DOLLAR BILL

When I first met William Ellis, he was already ninety years old. I was struck by his ability to recall events in his past with a clarity of mind that was much brighter than my own, though I was nearly half his age when we met. William Ellis was born and raised along Florida's wild and pristine Ocklawaha River during a time before the automobile had arrived. To Bill, the Ocklawaha was a magical, mystical and holy place. He told me once that it had been created when a ribbon fell from God's hair.

Bill's best friend was ol' Doc Ziegler, a man revered to this day in Putnam County as one of the best "can do, will do" old-time physicians around. Bill and Doc liked to go fishing on the Ocklawaha. Bill, known to have a mischievous streak, especially liked to take Doc under low-

hanging tree branches so that he could bump a branch with his oar to get a water moccasin to fall into the boat. You see, he liked to watch Doc tiptoe around the gunnels of the boat until he could swat the snake out with an oar. All the time Bill would be laughing, "Oh, those are just those little copper-headed-rattle-water moccasins. They ain't gonna hurt ya! Why, if they bite ya, they just gonna make you a little sick."

Well, one morning, William Ellis was working one of his favorite fishing holes when he looked on the bank and saw the largest water moccasin he'd ever seen in his life. It was eight feet long and as wide around in the middle as a man's thigh. Bill claimed that it had a pretty blue color to it. Why, his first reaction was to pull out his pistol. He cocked the hammer and got ready to squeeze off a round, when he thought, "That snake ain't really bothering anybody." So he uncocked the gun and returned it to its holster. He remained pretty curious about the snake, though, so he reached into the bottom of the boat and pulled out one of his long cane poles. With the tip of the pole, he reached over and poked the snake. It didn't react much, so Bill, feeling a little bolder, ran the tip down the snake's back. He did it once, twice and on the third time something really amazing happened. That snake rolled over! Bill continued to rub the belly of the snake with the cane pole. Why, when he went home that night, he could hardly sleep for thinking about the curious events of the day. So, the next day, he returned to his old fishing hole and saw that same water moccasin up on the bank. He pulled out his cane pole and began rubbing the water moccasin's back. He would pet the snake with his fishin' pole each and every day, and each day he would get a little closer, a little closer and a little closer. One day, William Ellis found that he could actually walk up to that snake and rub its back with his bare hands. Then the snake would roll over and Bill would rub its belly. And it wasn't long after that

before William Ellis could actually hand feed that snake bream and shell crackers.

Now, this story always conjures up a disbeliever or two. So, let me set the record straight, once and for all. Back around the last turn of the century, word spread that you could catch twenty-five-pound largemouth bass out of the Ocklawaha. A whole bunch of them Yankee boys came down to get in on the bass-bustin' action. Now, who do you suppose they would hire as a fishing guide? Why, William Ellis! Nobody knew the river better than Bill. He would float those good ol' boys past his favorite fishing hole, and that snake would be laying up there on the bank. Bill would shout out, "Hey, look at that giant water moccasin just layin' up there on that bank. Whew! Why, I bet you boys ten dollars that I can go up there and pet that snake with my bare hands." Well, there was just no shortage of Yankee boys willing to give up ten dollars to see some dumb southern boy get bit by a giant water moccasin. Imagine their disbelief when William Ellis not only rubbed that snake's back, but also stuck a fish down its mouth! It happened so often that all of the boys down at Leon Neon's Bait and Tackle Shop started to call William Ellis "Ol' Ten Dollar Bill."

William Ellis was a philosopher who believed that God created this world and that all the plants and animals were put here by God with the right to be here. He believed that mankind had no right to interfere with the laws of God and laws of nature. So he did his best to live in harmony with his Ocklawaha home. One afternoon, he

was floating past his ol' fishin' hole and saw his slithering friend up on the riverbank. But as he drew nearer, he felt a heaviness fall upon his heart. As he got closer and closer, he couldn't believe what he saw. Someone had walked up to that snake, perhaps just the same way Bill had done so many times before, but instead of petting the snake's back, they blew off its head with a shotgun. Its remains were left to wither on that sacred place where one of God's men and one of God's beasts had found a remarkable friendship. Bill felt riddled with pain and anger, and he instantly contemplated revenge. But no one ever admitted responsibility for killing the snake. And it was a long time before Bill wanted to go anywhere near that fishing hole.

Then one afternoon, he felt a strange calling. As he drifted his worn, paint-flaked skiff past the place where his old friend used to lay, he was surprised to see twelve young water moccasins stretched out on the riverbank. He drifted his skiff close to the river's edge and quietly slipped the anchor into the water. Then he carefully reached into the bottom of his boat and pulled up a cane pole. To his amazement, he was able to rub the backs of each one of those little water moccasins. Each one rolled over so that he could rub its belly. William Ellis was astonished! He returned the cane pole to the bottom of the boat and started to pull up the anchor. It snagged on something, and when he pulled it up he was shocked to find, attached to the anchor, the body of a man, so badly decomposed that

Bill could not tell who it was. The corpse was covered with small water moccasin bites.

William Ellis cut the anchor loose. He fired up that ol' beaten skiff as the sun began to set, and the great wash of evening fell over the Ocklawaha. A great blue heron glided over the bow. Bill headed home thinking, "The Lord sure does work in mysterious ways."

LEONDATEH (LEON-DA-TAE)

One afternoon, I went over to join my old cracker friend, William Ellis, for lunch. While there, I had to go out back to use the "facilities." When I came back into his cabin I asked, "Hey Bill, do you think someday you might get some indoor plumbing?" He told me flatly, "Nope; I don't like the kind of people it attracts."

We sat down to a nice lunch of swamp cabbage, corn bread and some delicious muscadine grapes. I remarked to Bill, "I didn't realize that you were a vegetarian." A scowl darkened his face as he replied, "D'you know that word 'vegetarian' was derived from an Indian word that means 'lousy hunter'?" Jokingly, I asked Bill if he had ever been to any of those vegetarian lodges. I told him that instead of having a moose head mounted over the fireplace, they would hang a fresh stalk of broccoli. He didn't think that was funny, but he agreed to regale me with a tale of his past anyway.

Now, I wasn't surprised to find out that William Ellis had outlived his wife. After all, he was in his nineties. But I was surprised to learn that he had actually outlived her by many years. You see, William Ellis was married to a beautiful Seminole Indian girl named Leondateh. He called her Leonda. She taught herself how to sing and play the guitar. She could play all the songs out of the Baptist hymnbook, but she preferred to apply her music to her own culture. She would find a quiet place to sit, strike minor and dissonant chords on the guitar and raise herself to a spiritual level, where she would write beautiful songs like "The Dance of the Sand Hill Crane," "The Season's Change" and "My People, the Seminole."

Leonda was quite a good musician, but she didn't care to play for folks like you and me. She would rather take that guitar out into the woods and sing songs to the animals. And you know something? After a while, there were a lot of animals. As the animals learned that they could trust Leonda, they began to show more and more of themselves. Once they discovered that she loved them, they became completely uninhibited. From this, she conceived of a great revelation about life: if you love something enough, it will give up its secrets. She imparted this revelation to William Ellis. They shared the depths of their hearts, and their love grew unconditionally.

One morning Leonda was out in the woods singing a song to some warblers when a chameleon fell from a tree and landed on her arm. She watched it change from its

green color to match the beautiful bronze hue of her skin. And when she set it back down on the earth, she watched it return to the color of its environment and disappear. From this observation, she conceived of another great revelation about life: if we are to survive, we must be like the chameleon; we must have the ability to change, and more importantly, we must be able to blend in and live in harmony with our environment. Again, she shared her revelation with William Ellis, and together they built a little cabin out of cypress on the banks of the Ocklawaha. There they lived, loved, gave to the land, took from the land and tried to live like that chameleon, seamlessly blended with the environment.

Then, in 1928, a great storm came across the state of Florida. We hear today that there were no storms worse than Katrina or Andrew, but the storm in 1928 killed more than four thousand people. Most of these folks were killed when the hurricane blew all of the water out of Lake Okeechobee and dumped it onto the surrounding countryside. Even along the banks of the Ocklawaha, the water rose so quickly, in the dead of night, that Bill and Leonda's cabin was completely covered in a matter of minutes. They barely made it out of the cabin alive. But suddenly, in a moment, Leonda was lost. Bill kept calling to her, only to have his calls blown back into his mouth by the hurricane wind. He dove beneath the dark waters, feeling around for her. He became exhausted and tried to rest while holding on to a tree, but the trees were covered with

rats, snakes and bugs, all trying to escape the floodwaters. Even after the waters receded, Bill never found a trace of Leonda, though he ceaselessly searched for her. And in his search, he realized that Leonda had left a last revelation about life: no matter who you are or what you have, it can be taken from you. In a moment it can be gone. William Ellis's heart was broken.

Then one afternoon, Bill was walking along the banks of the Ocklawaha and saw a guitar case wedged into the notch of a tree. After a struggle to get it down, he opened the case. It was Leonda's guitar, and it still had the strings on it. Bill picked up the guitar and embraced it; a flood of tears came pouring from his eyes. He cried inconsolably, and when he could cry no more, he dragged his thumb across the strings. The guitar wasn't really in tune; it just made a minor and dissonant sound. All of a sudden, a family of raccoons came out into the clearing, followed by a big buck, his doe and a fawn. Next came a gray fox and a black bear. William Ellis again dragged his thumb across the strings, and all the alligators and turtles began to congregate on the banks. A great blue heron flew in, followed by a number of noble and sassy anhinga, which began draping their wings to dry. As more and more animals arrived, they all peered at this broken man embracing a guitar. William Ellis plucked the first string of that guitar, and an eerie silence fell over the woodlands. Then, as if carried by the wind, he heard a voice. It was the voice of his beautiful Leonda. He could not see her, but he could feel her spirit all around him. She

assured him that she had gone to the place where the spirits go and that someday they would be reunited there, but until that time, she would remain by his side. She told him that it was time to mend his broken heart, and she sang out her song of the sand hill cranes. In a moment, the sky darkened with the flutter of giant wings as thirty sand hill cranes swooped in and formed a mandala, a perfect circle of cosmic order, all around William Ellis.

Leonda explained, "My people believe that the whole world is a circle. When we make our camp, it is always in a circle. When the eagle builds its nest, it is always in a circle—everything in the circle is one thing. I am in the circle with you always. Be no longer sad with heavy heart,

for I am with you even though you are without me. I am the one." William Ellis closed his eyes. He felt the air cool, and he began to breathe deeply, filling his lungs with new air. He felt the heaviness leave his chest.

Suddenly, the first string on the guitar snapped. It broke the silence like the sound of a gunshot, and when he opened his eyes, all the animals were gone. Though the moment dangled incomplete, something beautiful remained. As he rose from his seated position, he could feel new strength in his limbs. He looked toward the heavens and gave thanks.

So, you want to make William Ellis mad? Just ask him, "Hey Bill, how come you never got remarried?" He'll tell you that's a stupid question, because he knows that he has his beautiful Leonda by his side at all times.

I noticed the guitar case under his bed one afternoon. He broke it out and showed it to me. He still had not replaced that first string. But what does that matter? William Ellis does not play the guitar. He just likes to hold it and dream about all the wonderful things Leonda taught him about life, things she had learned from nature. He raised one eye up at me and said, "I bet you got someone waiting for you over there…you know, the place where the spirits go?" I replied, "Well Bill, I probably do. It might be the good Lord, or it might be the devil himself." One thing is for certain: we are all heading toward that day of revelation. I can tell you that William Ellis is looking forward to it with great expectation. But when I left him that day, I had the strangest feeling that it was not going to be happening soon. I can't say why I feel

that way. William Ellis is far into his nineties. Maybe it's because I know that he has more stories to tell. I don't know about you, but I want to hear them.

BIG FISH

Well, you would have thought I had already asked questions about fishing a long time ago. I've known that ol' cracker for some time now. That old man had lived his whole life as a fishing guide on the St. Johns and Ocklawaha Rivers. Did I think that because fishermen were both philosophers and notorious liars I wouldn't get a straight answer? All right! The time had finally come once and for all to pop the questions.

I walked for some time beneath a leafy canopy along the banks of the Ocklawaha on my way to Bill's cabin. The shadows of the cypress were stretching dark arms over the water. The river was moving quietly, curving snakelike through the wilderness. The day had already begun its slow decline into twilight. Songbirds put sound and color into the trees. The air was cool and sweet. Every now and then you could see silver ripples on the water where bass and bream were swirling.

Bill had spent most of the afternoon up around Indian Mound gathering some fresh turkeytail mushrooms. He would dry them in the sun, grind them up into a powder and make tea with them. He drank it every day; perhaps

that's why he has lived so long. Bill always liked that area around the Davenport Mound. He told me once that it is still a place where spirits meet and mingle.

We sat down to some of that turkeytail tea, which had a pleasant flavor. It wasn't long after that I decided to pop the questions. "So tell me, Bill. I've been wondering for some time. What was the biggest fish you ever caught?" Now, Bill's face was creased with a thousand wrinkles, and his skin tanned like leather from years in the sun, but you could see a sparkle flash from his tired eyes when I asked that question.

Bill claimed that the biggest fish he ever caught was a catfish. "It was so big that I couldn't get it onto the scales. So, I took a picture of it. The photograph weighed eleven

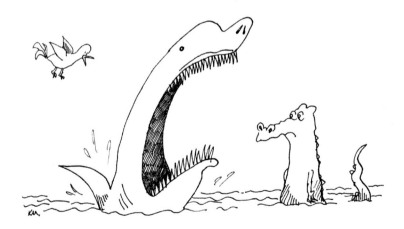

pounds." He was laughing at me now. Still chuckling, Bill continued: "Did you know that Ulysses S. Grant rode on this river in 1880?"

I shook my head, "Okay Bill, you got me on that one. So, what was the biggest fish you ever saw on the river?"

Bill leaned back in his chair and looked out into the distance. "I was fishing one afternoon down where the Ocklawaha runs into the St. Johns River. The water there is about forty eels deep. I was watching a gator slide across the water when all of a sudden I saw the dorsal fin of a very large fish. In fact, it was a big ol' shark. It eyeballed that gator and picked up speed. The gator turned to face his attacker. The shark swam past the gator, then turned at remarkable speed and hit the gator in the side and the belly. There was a great crushing of bones and flesh as the water became stained with the blood of that gator. I was amazed as I watched most of that gator disappear down the trunk of the shark. And that was the biggest fish I have ever seen on that river."

We walked out of the cabin and down to the water's edge. It was dark now. A barred owl cried out, "Who cooks for you?" I turned on my flashlight and cast it on the water. Silently sliding through the cattails and cypress knees was a big gator. Its eyes flamed like coals from hell as the flashlight swept the inky surface of the water. Bill advised that I spend the night.

When I awoke the next morning, Bill was frying up some bream. He already had a pot of grits going. We washed down that breakfast with more of the turkeytail tea. As I

made my way back through the woods to the highway, I wondered if Bill was pulling my leg with that shark story. But, after a little research, I found out that sharks do frequent the St. Johns River, including bull and tiger sharks, as far south as Big Lake George.

THE GHOST HOG

Wild hogs, often referred to as feral hogs, are found in every county in Florida and have an estimated stable population of over 500,000. Only Texas has more wild hogs than Florida. They are hoofed mammals, stocky, with short legs and a long snout. They typically have solid-color hair. Males are usually larger, with an average weight of around two hundred pounds. They have four continuously growing, self-sharpening tusks, an acute sense of smell and excellent hearing. They can host many diseases and parasites like cholera, tuberculosis, salmonella, anthrax, ticks, fleas and lice. Their opportunistic and omnivorous nature brings them into conflict with people and wildlife.

As prevalent as the hogs are, I bet you can't find a good ol' boy in the whole state of Florida who doesn't have a story to tell about wild hogs. It's amazing how this critter, which was supposedly imported here some five hundred years ago by Hernando de Soto, has found its way into the folklore of the people. There are some places in Florida that are so overrun with wild hogs that birds are scarce,

and even rattlesnakes, water moccasins and alligators have sought security in another location. A wild hog will eat just about anything, including birds, bats, rats, rabbits, skunks and foxes. They are not even bothered by water moccasin bites; they eat them, too, head and all. It's even dangerous for an armed man to travel through their territory. Wild hogs are ready to fight at any time, and they would rather die in their tracks than yield an inch of ground to a foe.

There are a lot of hog yarns. There's one story about a giant wild hog named Hogzilla that was over twelve feet long and weighed over one thousand pounds. Another one tells the tale of a boy who killed a thousand-pound wild hog with a pistol. Florida's Black Hat Troubadour, Will McLean, used to tell a story about an alcoholic burro that hunted wild hogs. After the burro had about a pint of beer, he would run through the swamps with the dogs. He'd catch a hog by the ear and sit on it until his owner could get there. But I was more interested in a story told to me by my old cracker friend, William Ellis. He didn't care that much for wild hogs, although he admitted to eating a pork chop or two in his time. He told me that he felt like they really did not belong here.

We were sitting in Angel's Diner in Palatka, Florida's oldest diner, having a bite to eat. The waitress there was a good ol' gal named Ruby, and she had just delivered us each a cup of hot coffee and taken our order. He began by telling me, "Over in the big bend part of Florida, where nights get the blackest, the bullfrogs croak the loudest and

owls hoot the lonesomest of any spot in creation, people fear the terrible Ghost Hog." He took a little sip of his coffee and looked at me with his ancient eyes to make sure I was listening. "Ya know, it seems to me that folks are always afraid of something that they can't kill. Sightings of the beast have been reported from Tate's Hell all the way down to Steinhatchie. Some folks just laugh at the stories, saying that they're just a tale about an albino hog. But if that were true, how come no one has killed it, and why do the stories go back for generations?"

I asked Bill, "Why does everyone call it a 'ghost' hog?"

Bill replied, "Because it scares people to death and makes them do stupid things. One old fool emptied his rifle on that hog, and the hog still chased him into the swamp, where hungry gators and mean ol' water moccasins were waiting. Another ol' fool watched the slobber dripping down its jowls, took one look into those blood-red eyes and got so scared that he accidentally shot off his own foot. The scary part is that the Ghost Hog appears and then disappears without a trace. Now that ought to send those cold shivers up your spine." It did!

BLACK BEARS

I've been fishing my whole life. I used to think that it was about the fish, but now as I sift back through the years, I've come to realize that it was more about getting out there,

on or near the water, and communing with nature. Fishing is participating in an event that has been going on ever since mankind set foot on this planet. You can fish all alone and carry on that conversation with yourself that is bound to make a philosopher out of you, or you can enjoy the companionship of fishing with your friends. I don't like to go fishing with just anybody though. I prefer to fish with a special friend, and one morning I headed for Deep Creek with my old cracker friend, William Ellis. Now, William was a man who represented to me everything that was real about Florida, especially that part of Florida that seems to be fleeting.

We entered the mouth of Deep Creek, where there were huge alligators on the bank that sat like sentries guarding a gate. There were a few gators lying silently in the water, close to the banks, waiting for some poor critter to come get a drink. Those alligators can be fast. My old friend Chris, who wrestled alligators for a living, told me once that an alligator can get up on its hind legs and outrun a racehorse for a short distance. We were in Bill's old paint-flecked skiff. He sat up in the bow next to a five-gallon bucket that had a cast net folded up in it. He not only knew how to throw a cast net, he knew how to make one, too. He was up there looking for signs of a school of mullet. That was his favorite fish. He called them "cracker caviar."

As we trolled farther up this beautiful creek, we came upon a stretch of quiet water beneath a canopy of water oaks and cypress. The shoreline was layered with ferns and

grasses. Then we both caught a glimpse of a black bear amidst the palmetto spear points. Almost as quickly as we saw the bear it disappeared. I said to Bill, "I never hear you talk too much about black bears." Bill replied, "Well, I guess I ain't had too many problems with those critters. One time I was camped out down by Salt Springs. It was so hot that the air felt like a bloodhound's breath. The bugs was pretty bad, too. You could swing a quart jar through the air and catch a gallon of them skeeters. I had to build a smoky campfire and sleep close to it so that I would not be

eaten by those flying cannibals. They was big as pelicans. When I woke up at daybreak, I heard something rutting around the campsite and was surprised to see that it was a big momma black bear. I was more than an arm's distance from anything that I could protect myself with, so I just laid there and played like I was a dead man. The bear came over and nudged the back of my neck with a little snort. Its breath smelled like rancid garbage, and I was terrified. I really thought that I was going to be her breakfast. Then the bear went down my backside sniffing and snorting some more until she got to my feet. She took one whiff of my toes and went running off into the woods."

He had himself a good little laugh over that and continued: "My momma used to tell me a story about an Indian woman who made her living cooking for a bunch of those turpentine boys. They'd be out working in the woods, shoot something and then bring it to the woman to dress it out and cook it for them. Well, one day those boys shot a small bear and brought it to the woman. When she cut it open to dress the animal, she found that the bear had a cub and that it was still alive. She cleaned it all off and suckled it to her own breast to keep it alive. Before long, the little thing came around and she continued to feed it and take care of it until one day when it went crazy and attacked one of her own children. She had to kill it. I guess you never know about wild things."

Bill continued to pontificate on bears; he explained that his daddy had a bad run-in with a black bear when he was

just a boy. He said, "Daddy was fishing down in a creek that was real close to the house, and he had just caught a bunch of those speckled perch. He cleaned them up right there alongside of the creek. Then he made a pouch by weaving a bunch of palmetto leaves together. It was a craft that his daddy had taught him. He put the fish in the pouch, put the pouch in a burlap sack that he threw over his shoulder and then he headed home. He said that he really wasn't paying that much attention to what was going on around him until he heard the thunderous crushing of brush. When he turned in that direction, he saw something so big running toward him that he first thought it was a buffalo. On a second glance, however, he realized that it was a gigantic black bear that was wasting no time. My daddy threw the sack of fish on the ground and started running for the house. That bear stomped down on the sack of fish and tore it to shreds with its claws. Then, without even eating a single fish, it took after my daddy once again. Daddy had gained a few steps on the bear, but everyone knows that you can't outrun a bear. Daddy was getting closer to the cabin and yelling for his momma as he pulled off his shirt and threw it to the ground. That bear pounced on his shirt and ripped it apart before starting after my daddy yet again. Daddy reached the gate, but he didn't have time to open it. So, he leaped over it. The bear did the same thing, but just as soon as it got airborne my daddy's momma discharged both barrels of a ten-gauge shotgun and hit that bear right in the face. It didn't slow him down any, but it surely turned

him around and sent him down the road. My daddy was afraid of bears ever since, and he had a whole bunch of grateful respect and love for his momma."

Bill and I didn't catch a single fish that day. There I was, in a place where deadly water snakes breed, where the wind blowing through the trees made music from invisible instruments, where nature is ever giving. In that backdrop, I listened to my dear friend tell a couple of stories about black bears and felt all the richer for knowing him and being there. It's like I said in the beginning of this story; it's not about the fish.

Florida's black bears are the smallest of the three species of bear in North America. They are shy and secretive. Their typical weight is less than three hundred pounds, although some five- and six-hundred-pound bears have been reported. They can run fast and are excellent tree climbers. At one time, there were over twelve thousand bears in Florida. Their numbers have dwindled to below fifteen hundred because of habitat destruction. The number one killer of black bears in Florida is the automobile. There are two black bear festivals in Florida. One is in Umatilla, and the other is the Forgotten Coast Black Bear Festival in Carrabelle.

WHERE IS HE NOW?

So what ever happened to William Ellis? What happened to the man who spent nearly one hundred years of his life

on one tiny speck of this planet? That tiny speck, Florida's wild and pristine Ocklawaha River, was his whole universe. He was born and raised on its banks and baptized in its tannic waters. It was where he met and fell in love with his beautiful Seminole bride, Leonda, and also where he lost her in the great storm of 1928. His whole life, joys and sorrows, played out alongside those mystic waters. But where is he now? What ever happened to William Ellis?

Well, William Ellis eventually moved back into the cabin that he and Leonda were flooded out of, and he continued to make a living as a fishing guide. He always had plenty of fish to barter with local folks for fruits and vegetables. You know, it's where he wanted to be: his cabin, the river, him all alone. But he didn't consider himself alone because Louise was there. She may have been the only raccoon in the whole world with a compulsive eating disorder. She was at the cabin every day, breakfast, lunch and dinner, sitting right up there on the table, joining Bill. Oh, they had great conversations, though they were mostly about food. Louise liked to complain, "Fish from the river ain't as good as it used to be. It's got a funny taste to it." And Jasmine was there, a huge, beautiful, red-shouldered hawk, always perched on the windowsill. She was the self-appointed guardian of William Ellis. She would fly off on thermal wind currents, circling high above the Ocklawaha, with her yellow eyes piercing in rapture the water and land below. There wasn't nothing going on that Jasmine didn't know about. Then there was Sam, an old gray fox. Now, I'd be

the first to agree that Bill should never have given that fox a sip of his corn liquor. Sam's been hanging around ever since. And lastly, there were the kids: five little baby otters running all over that cabin, always getting tangled up in Bill's legs. He had to get after them with a stick, hollering, "Git, go on, git!"

So you see, William Ellis had everything he needed: a place to live, a way of making a living, high-quality food and precious friends. He didn't want or need anything else. So my question to you is this: Why do you suppose some no-good, meddling bureaucrat from up there in Putnam County thought he had to send a social worker out to check up on Bill? He'd gotten along just fine for almost one hundred years.

And why do you suppose they sent someone out who was born and raised in New York City, someone who knew nothing about the "cracker" life? Why by the time Little Miss Narcissa even got close to the cabin, she was already so eaten up with bugs that she couldn't see straight. Jasmine saw her coming for miles. Sam followed her in for the last half-mile. Bill and Louise knew she was there, but they didn't care. Narcissa snuck up to the cabin, peered through the window and eyeballed the oversized raccoon, up on the table, eating off of the same plate as a very old man. And the old man was talking a mile a minute to the raccoon.

Narcissa snapped her head back, whipped out her clipboard and wrote, "The cabin is filled with disgusting vermin, and the old man appears demented—thinks he can

talk to animals." Then she walked behind the cabin and noticed an unusual structure. It appeared to be a toolshed. It had a quarter moon carved on the door. She opened the door and beheld a bench seat with a hole cut in the middle of it that dropped down into a dark abyss. There was a Sears, Roebuck catalogue and a *Farmer's Almanac* next to the hole. She slammed the door, whipped out her clipboard and wrote, "Unsanitary conditions!" Then she was out of there. She never even took the time to talk with William Ellis. If she did, she would have learned that animals can communicate. In their own way, they can speak. Just because they might not be speaking to you doesn't mean that they can't.

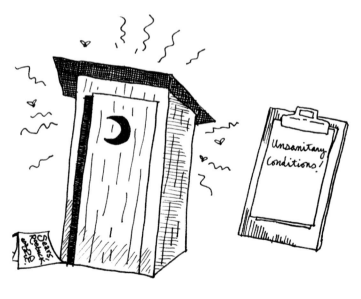

The next day, two deputies from Putnam County arrived at Bill's cabin. They were nice fellows, and they took Bill into Palatka to the county nursing home. "Welcome to the Golden Years Nursing Home, Mr. Ellis," said a woman in a nurse's uniform, who seemed to have the same eating disorder as Louise. She was equally wide, from her ankles to her neck. She continued, "Oh, you're going to get a lot of rest, good food, medicine and there's plenty of those widow women too!"

Now, we all know that such places are great for some people, but not for William Ellis. Under the cover of darkness, he snuck away and was back home at his cabin having breakfast with Louise and Sam the next morning. But those deputy fellows came back, too, and again William Ellis was escorted to the nursing home. Again he snuck off. Well, this went on for some time, until one afternoon, those deputy fellows returned, and they were not nice guys anymore. They'd grown tired of fooling around with this old man and treated him poorly. Louise, Sam and Jasmine became very concerned. Jasmine followed them all the way into Palatka to see where they were taking him. It's a good thing that she did, because William Ellis did not return the next day as he always had before. He wasn't there the following day either or the day after that. So, with Jasmine in the lead, Sam and Louise made their way to the Golden Years Nursing Home.

It was dark, and they had to chew and claw their way into the building. They followed their noses down a long

corridor until they found Bill's room. When they entered, they could not believe what they saw. Their old friend was lying on his back, his mouth wide open, his eyes rolled up in a stupor-sleep. The flesh of his cheeks had caved in, and he had dark circles around his eyes. Louise jumped up in bed to try to wake him. "They must not be letting him up to go to the bathroom," she lamented. Then she saw the wide leather straps tied around Bill's wrists and ankles and fastened to the bed frame. If you have ever seen the dexterity that raccoons have with their digits, then you know Louise had no trouble unfastening the bindings. But the one around Bill's left ankle was stuck, so Sam had to chew through it. "They must be giving him sleeping pills," Louise cried as she tried again to wake him.

When Bill opened his eyes and saw that he was in the company of his precious friends, a big smile came across his lips, and he rose, a little wobbly-legged, from bed. You just have to close your eyes for a moment to imagine the next scene. It's a county nursing home, late at night, and here comes the most unlikely trio: an unsteady old man, an oversized raccoon and an alcoholic-looking gray fox sneaking down the dimly lit corridor. The only thing between them and freedom was the night nursing station and Big Savannah, the nurse mentioned previously. As they crept closer, they could see Big Savannah sitting behind the desk. On her desk, in the middle of a bunch of papers, was a large barbecue sandwich, a big bag of pork rinds and a thirty-two-ounce Slurpee. She may have been focused on

her meal, but everyone knew that getting past her was not going to be easy.

Sam ran back down the hallway to the place where he and Louise had gained entry to the nursing home. He went back outside and signaled to Jasmine, who was perched on the flagpole, and then came back in and down the corridor to where Bill and Louise were waiting. Big Savannah was taking a long slug off of that Slurpee when Jasmine flew up against the window behind her desk and about scared her half to death. Sam said later that she looked like a boiled owl. When she spun around in fright, she saw this huge hawk fly up against the window again. At that very moment, Louise, Sam and Bill chuckled as they made their way out the door. Within moments, Big Savannah regained her composure and resumed her relationship with the barbecue sandwich. She had no idea that William Ellis was long gone.

By the time they made it back to the cabin, Bill was exhausted. Louise, Sam and Jasmine had never seen him like this before, and they were very concerned. Bill lit the kerosene lamp and then walked down to the water; he removed his soiled clothing and took a bath in the Ocklawaha.

When he came back in, he grabbed a piece of paper and began to write something down. When he finished, he called all of his friends together and said, "You know, my precious little friends, those deputy boys are gonna be back. Only this time, we're not going to be here." Sam, Louise and Jasmine became more disturbed. William Ellis confided to

his dear friends that the time had come for him to join his sweet Leonda. He told them not to be sad, for they would all be reunited in a very wonderful place. He hugged each one of his friends and climbed into bed. Looking over at Louise he said, "You know what to do. Don't ya honey? I love ya!" Then William Ellis closed his eyes, never again to reopen them on this planet. Jasmine saw his spirit leave his body, and she lifted off with it and followed it to the place the Indians call "Where the Wind is Born." Sam howled at the moon. The otters all took refuge in the river. Louise jumped up on Bill's chest and stared into the face of her dear old friend for a long time. Then she licked his closed eyes and his mouth, leaped over to the table and knocked over the kerosene lamp. It shattered into hundreds of pieces, sending fingers of kerosene across the floor, quickly followed by orange flame. Those orange flames spread until they consumed the whole cabin, turning it into nothing but smoke and ash.

It was several days before I heard what had happened. The day I went out there, it was raining. I leaned my back against an old cypress tree and watched, for the longest time, the water washing the ashes into the river. It was Bill's river and his home. I saw Louise climb out from under the rear seat of Bill's boat. She was so rotund that she had a hard time getting free. She grabbed a glass jar that was floating in the bottom of the boat. It was a jar that Bill carried his drinking water in. This time it contained a piece of paper. Louise gave it to me. Curious, I removed the cap

and took the paper from the jar. Written on it was this: "The Ocklawaha is the only life I've ever known. If the Lord is equal with his giving in the next place, I will do very well. Please look after those baby otters. Sam, Louise and Jasmine can take care of themselves. Please tell everyone to look after the river. Leonda's people called it 'twisted water.' To me, it's one of God's places."

Now, you may wonder how I know this story to be true. William Ellis didn't tell me. Dead men tell no tales. I can only say that animals can communicate; they can speak. I leave you with just one question: are you listening?

MEDICINE MAN OF OCKLAWAHA COUNTY

Not far from Bean Creek, in an area known as Little Turtle Cove, there lived a young couple who had an especially beautiful daughter. Annie was a gift from God, perfect in every way. Like the wind-dancing mane of a golden palomino, her long hair would fly through the air as she chased her little black dog, Lucy, across the yard. Lucy weighed about sixteen pounds and had many physical idiosyncrasies. But Lucy's imperfections only made Annie love her that much more. Besides, what Lucy lacked in physical beauty, she made up for with heart and intelligence. Annie loved Lucy so much that she wrote a song about her that went, "Little Lou, little Lucy / blacker than an old chunk of coal / Little Lou, little Lucy's / got a heart that's

pure as gold." Annie would sing the song over and over, and little Lucy would get up on her hind legs and dance pirouettes across the yard.

One day, Annie became afflicted with a dreadful illness. It was unlike anything anyone had ever seen. Her little body became rigid and board-like. Her left arm became shriveled and curled under her chin. Her eyes would roll up into her head, and she was wracked with terrible convulsions, letting out cries that were of the most soul-disturbing kind. Her parents didn't know what to do. So they wrapped her up in blankets and took her to Putnam County to see ol' Doc Ziegler. Doc was one of the most respected physicians around. Annie's parents felt that he'd surely be able to help them. But ol' Doc had to tell her parents that he had never seen anything like this before either. Don't get me wrong; Doc's not the kind of man to give up without a fight. He kept Annie for several days and tried all kinds of different remedies, but Annie just got worse and slipped further away. Finally, Doc had to tell her parents that he was sorry. He sighed, "You might do well just to take this poor child home and let her die in the peace and comfort of her own bed. I'm very sorry."

Despairingly, Annie's parents wrapped her back up in the blankets, put her in the wagon and returned home. They placed her back in her bed, and little Lucy, who looked so sad, lay right under the bed.

Annie's parents went out into the kitchen and sat across the table from each other. Holding each other's arms,

they began to cry. And when they could cry no more, they prayed. They prayed until they fell into a restless sleep, their heads against the tabletop. About sunrise they heard a noise at the door. It was Oshaman, the medicine man of Ocklawaha County.

Oshaman was part Seminole. He was part Choctaw, part Creek and even part African. His great-grandmother had been a runaway slave. He was a direct descendant of a long line of medicine men that dated back for hundreds of years, all the way back to a tribe from the Southwest known as the Anasazi, or the ancient ones. Oshaman carried on his waist a little lizard-skin pouch that actually contained the dust remains of Anasazi warriors. It had been handed down from generation to generation, with the specific instructions that it was to be used only when making very powerful medicine. Unlike the physicians of our time, who use specific agents to treat specific diseases, Oshaman used the roots, leaves and berries of plants. He used wild mushrooms and pure waters. The substances that Oshaman used boosted the body's immune system so that the body could essentially heal itself. He treated not only the physical but also the spiritual, and he was a great teacher of how to be well and stay well.

Annie's parents took Oshaman into Annie's room. He walked around the bed several times and then declared, "We don't have much time; we must hurry." He explained to Annie's parents that they should leave, because they had generated large amounts of negative energy by fearing the

loss of their daughter. Oshaman directed them to gather wildflowers from along the banks of the Ocklawaha. He told them that they should only be thinking of Annie getting better. They left quickly to do as they had been directed.

Oshaman then picked up little Lucy and placed her next to Annie in the bed. He went about the house and opened all of the windows. He went outside, and with a big stick he drew a circle in the dust around the house, leaving it open by the doorway. He reached into his pouch and produced two magpie feathers, which he hung over the doorframe. He then produced two ears of Indian corn, and holding one in each hand, with his arms out stretched, he walked into the open part of the circle and began to chant, "Oh, Blue U, Blue U, Blue U spirit. Come to us now, come to us now." The clouds in the sky began to churn, swirl and boil, as if the world were spinning wildly on its axis. The sky was in turmoil; then, as suddenly as it had become stormy, the clouds faded away, leaving a peaceful turquoise sky.

Annie's parents returned with their arms full of all kinds of wildflowers. Oshaman took the flowers from them and directed them to begin singing their favorite hymn. He advised them that no matter what they saw or heard, they were to remain outside of the house. Then, with his arms filled with wildflowers, Oshaman reentered the house. He cast the flowers about the kitchen. The house began to shake and tremble as if a freight train were passing by. Picture frames on the walls rocked back and forth. Oshaman walked into Annie's room and continued to cast

the wildflowers about. A mirror on the wall shattered into innumerable pieces. Little Lucy jumped from the bed and ran to hide under the dresser. She was afraid, but Oshaman was not. He walked up to Annie's bed and placed the remaining wildflowers around her. He stretched his arms over her body and began to chant, "Oh, Blue U, Blue U, Blue U spirit. This child is a child of your children's children. Come to us now, come to us now." Suddenly, Annie sat upright in bed. Her head rolled back, her mouth opened wide and from her throat extended the head of a serpent. It was long and black, with blood-red eyes and slimy fangs. Oshaman quickly produced a liberty cap mushroom and offered it to the serpent. The serpent extended its head to receive the gift. It seemed pleased by it. Oshaman produced another mushroom and held it out even farther. Again, the serpent extended itself to accept the gift. Then Oshaman went to the foot of the bed and presented his last mushroom. The serpent leapt from Annie's throat and attacked Oshaman. It wrapped itself twice around his neck and began constricting. Oshaman could not breathe; his lips turned blue, and he fell over on the floor. Little Lucy ran out from under the dresser to Oshaman and began to tug at the lizard-skin pouch attached to his waist. She pulled it free and ran over to Annie's bed and jumped up, and holding that pouch in her teeth, she shook her head from side to side, sprinkling the pouch's contents all over and around Annie. She then turned to Oshaman, who was lying on his back. The head of the serpent had disappeared

down his throat. Still holding the pouch in her teeth, Lucy leapt from the bed and ran over to Oshaman. Standing on his stomach, she began shaking her head from side to side, causing the remaining contents of the pouch to fly through the air. As soon as the dust of the ancient Anasazi warriors touched the skin of the serpent, it withdrew its head from Oshaman's throat and emitted a hideous scream. It was as if the dust of those ancient Anasazi warriors was like acid on the serpent's skin, and it slowly dissolved away completely.

Annie's parents, hearing that scream, came running into the house. They helped Oshaman to his feet, and then they all went to Annie's bed. Her left arm was resting comfortably alongside her. Her little body was no longer rigid. They could see her lips moving, and they all bent over the bed to hear what she was trying to say. "Little Lou, little Lucy, little Lou, little Lucy, little Lou Lou, she's a pal of mine." Then Annie opened her eyes as fat tears came rolling down her cheeks. Lucy licked the tears away, and everyone hugged one another in a moment of great joy.

Oshaman went outside, closed the opened portion of the circle and removed the magpie feathers from over the doorway. He then went back inside and started to attach the small lizard-skin pouch to his waist, but he paused, smiled at Lucy and bent down to attach it to her collar. Then, almost as instantaneously as he had come, Oshaman was gone, and Annie was never sick again. Folks around Bean Creek said that they saw Oshaman walking through the woods that day. They claim that he was laughing and

singing this song: "Little Lou, little Lucy, little Lou, little Lucy, little Lucy, she's a pal of mine."

ALBERT AND MARTIN

It's not like Albert and Martin were deliberately trying to break the law. Making moonshine required a grow-your-own-beverage philosophy—a bit like having a garden… although a lot of folks who drink moonshine said that they could do without the garden. Making moonshine helped pay the bills, but making and selling moonshine is a tough business.

Let's dispel once and for all the notion that only mountain folks from Tennessee and Kentucky know how to make 'shine. That's an error. The best liquor is made in Florida swamps because swamp folks have enough time to make it right. Now, some Florida moonshiners will use sugar cane, but most prefer to use corn. Making good whiskey ain't easy. For one thing, you've got to allow enough time for the corn to sprout before the mash is made. If you're making moonshine in the same location all the time, you will be overrun with rats. A dead rat in the mash is not a part of the recipe. Florida moonshiners have been known to steal people's cats to help control the rats around the still. And once you've got the whiskey made, you've got to know how to taste it. First, get a cup of cool spring water in one hand and a cup of 'shine in the other. Cool your throat with the

water first, and follow it with the liquor. Then take another gulp of spring water to keep your throat from burning. That warm glow in your belly? Ain't nothing going to cool that.

So Albert and Martin got all their supplies together and hauled the pile into their little hiding place down in Cherokee Grove, alongside of Cracker Creek, where they planned to make a batch of their famous brew. (They now call Cherokee Grove "Princess Place," and it's one of the most beautiful spots next to Pellicer Creek in Flagler County.) The hardest part about making moonshine is the cooking. You have to constantly tend the fire to make sure that it doesn't make a lot of smoke. You don't want anyone, especially the law, to think that the woods are on fire.

Albert and Martin were a good team. They first put the corn in some clean, warm water, just enough to cover the corn, and left it alone for three days while the corn started to sprout. Then they poured the mash into a fifty-gallon barrel. Next, they dissolved about fifty pounds of sugar in some warm water, and when the sugar was dissolved they poured it into the mash. Then it was time to add some good old-fashioned yeast. They let the concoction ferment for four or five days before they began cooking it off. Albert and Martin had an old copper fifteen-gallon wash boiler that they used for a cooker. They took about twenty-five feet of copper tubing and bent it around a big barrel to make what's called the "worm." They placed the worm in a larger barrel of cool water and ran a lead line from the worm over to the copper cooker. The whiskey drips out of

the end of the worm that's sticking out of the water barrel and is caught in a large fruit jar. The last step is to put some charcoal in a funnel and filter the 'shine to remove the impurities.

Martin declared, "I'm going to be the tasting cook." Albert replied, "Martin, you've been drinking for so long out of fruit jars that you're getting a little notch up there on your nose." They both laughed.

And so it was, under the light of the Florida moon, that Albert and Martin started cooking. They filled so many fruit jars with their wonderful moonshine that they lost count. The plan was to float the brew up Cracker Creek in their boat to the old dirt road, transfer the cases onto a truck and carry them on into St. Augustine. Then they decided that since they had so many cases it would probably be a better idea to paddle up the Intracoastal Waterway instead. That way they could drop a couple of cases off at Moses Landing and Moultrie Creek before going up into St. Augustine by way of the San Sebastian River to deliver the rest of the goods and get their cash rewards. This is the most dangerous part of the business. You not only had to worry about getting bitten by snakes and eaten alive by those pesky saltwater mosquitoes everyone called "swamp angels," but you also had to worry about black bears, alligators and robbers. Word was out that mobsters like the Ashley Gang would come up this far north and steel a moonshiner's hard work. And as if that wasn't enough, you definitely had to worry about the law.

So Albert and Martin loaded up the boat and headed down Cracker Creek to the Intracoastal Waterway and went north toward the old town. The old boat was a wooden, paint-flaked skiff about eighteen feet long with a wide beam, and it was pretty heavy without all those cases of moonshine. It was loaded above the gunnels now with those heavy cases, and the kicker was having a hard time picking up speed. Once in open water, though, it gradually got moving pretty good.

It was a beautiful night. The gibbous moon shone clear as daylight. The water was calm. There wasn't a soul on the water except them. Albert was sitting up in the bow rolling a cigarette when all of a sudden the boat hit something, and he went flying through the air and into the water. Martin found himself thrown up against the cases of liquor. The motor screamed and reared up over the transom. Now, Albert was not a good swimmer and would have surely drowned had he not realized that he could feel the bottom with his hands, and when he stood up, the water barely reached his knees. In the darkness they'd run onto a sandbar.

After they determined that they were both okay, they tried to push the boat off the sandbar. But that boat was so heavy, and they hit the sandbar with so much force, that they could not budge that boat an inch. After much discussion, it was decided that they were going to have to stay right there until the tide turned around and lifted them up off of that sandbar. Now, sitting in a boat can be pretty boring if you don't have a fishing pole. They took turns taking little

naps lying out across the tops of the cases of moonshine. They didn't have any fresh water with them, and the longer they thought about it the thirstier they became. Imagine being in a boat filled with stuff to drink and being thirsty. They decided that the only way to deal with the temptation was to yield to it. So Albert opened one of those fruit jars from a case, and they started out just drinking a little sip. It was a ceremonial toast to their hard work. Their lips and throat burned, their nostrils flared and their eyes squinted and watered as the 'shine took away their breath. After that first big swallow, they let out a cheer. They congratulated each other and tilted that fruit jar once again. It was a little smoother now, and they both could feel a little warm glow in their bellies.

In life, there are usually two kinds of warning signs: unnatural signs, which seem to indicate effects to follow like the moon and stars shining brighter and their bodies feeling lighter, and luck signs, good or bad, which indicate observances or avoidances. It's bad luck to be drinking your own 'shine before you got it sold. Albert and Martin ignored both. They were having a real good time now, telling each other jokes that they thought were long forgotten. They were laughing, singing, slapping each other on the back and doing little dances, all the while drinking more and more of their homemade moonshine.

The next morning, Sheriff Watson got a report from some concerned citizens who said that there was a boat floating down the Intracoastal Waterway with two dead

men laying in it. When the sheriff and his boys got to the boat, Albert and Martin were still passed out. When they regained their consciousness, they were arrested and thrown into jail. Their precious cargo was seized by the sheriff.

At their trial, the judge said that he was disappointed with Albert and Martin for breaking the law but also that he sampled the evidence and found it to be of "exceptional

quality." They were both fined fifty dollars and had to spend ninety days in the county jail. Like I said in the beginning, making and selling moonshine is a tough business.

OLD STUMPY

Somewhere in a deep den, under the wide, spreading branches of a giant cypress tree, along the banks of the mighty St. Johns River, between Dunn's Creek and big Lake George, lives the biggest and meanest alligator there ever was, Old Stumpy. Some folks along the river said that he ate mules, women, dogs and children, and like the Loch Ness monster, he was hardly ever seen. Those few folks who have seen him claim that he was twenty feet long and always left tracks that attested to his missing left rear foot. All that he had back there was a stump. He must have lost his foot as a youngster in a fight with another alligator, or perhaps he lost it in a steel trap.

They say that on black, moonless nights you can shine a light across the river and see his harem, their eyes reflecting light like faceted crystals. But Old Stumpy keeps himself well hidden. After all, you don't grow old being a dummy. I think Old Stumpy knew that local folks had posted a big bounty for the man who could bring him in.

Bubba Clemson was raised on big Lake George, the second-largest lake in Florida. It's so big that the United States Armed Forces uses part of it for a bombing range. It

has enough salt in it to support some saltwater fish and plant species. It's a great habitat for alligators. This was where Bubba had hunted alligators his whole life. He earned two dollars per hide for every one over five feet. He would cut the gator's head off and leave it on shore in the sand. Then he would come back about a week or so later and pull the teeth out with his fingers. A pound of large alligator teeth would fetch about five dollars. Bubba wasn't afraid of enormous gators. Big Lake George and the St. Johns River were full of them, and the thought of a cash reward for Old Stumpy just made the deal that much sweeter.

Everyone knows that you don't hunt alligators in the daytime. You have to do it at night, and you need the proper equipment. Bubba always packed plenty of salt for the hide, a good rifle, a bull's-eye lantern, a harpoon and a good knife. Plus he carried with him all those years of experience at killing alligators. He recruited the help of his oldest son, Robert, for this special hunt. The challenge now was to find Old Stumpy.

Bubba and Robert launched their boat in Georgetown and cruised out to set up camp on one of those little islands between Welatka and Georgetown. For several nights they shined alligators, measuring the distance between their eyes to determine size, in the hope of spotting Old Stumpy. All the folks in the area began to relax a little, knowing that Old Stumpy's days were numbered. Then one night, Bubba and Robert spotted Old Stumpy, but as they got closer, he sank into the inky black water. All that remained were those

murky bubbles in the dark water. So Bubba and Robert returned to their camp that night, but they were never ever seen again. When no one had seen Bubba and Robert for several days, they called the sheriff. When the sheriff and a couple of his deputies came upon the little island where they had camped, they saw that everything was scattered about like a tornado had come through. There was a lot of blood on the sand. After a little searching they found Bubba's and Robert's boots, but no sign of Bubba and Robert. Their boat was pulled up out of the water and

undisturbed. Then, down by the water's edge, they spotted the tracks of a huge alligator. One of the alligator's feet was missing in the tracks. "It must have been a terrible death to be devoured by such a beast," said the sheriff. "It appears that the hunters became the hunted. We better warn everyone to be on the look out for that monster."

Fear returned to the homes along the river. The local gun shop sold out of ammunition. Families kept their dogs and children inside. The great bison have disappeared from our plains, as have the fur seals up north. But along the banks of the mighty St. Johns River, you'd better beware of Old Stumpy.

UNCLE ARTHUR

Uncle Arthur was sure proud of those bell-bottom trousers. He'd been wanting a pair of them for God knows how long. And, don't you know it, who was the one who got 'em for him? My momma, Uncle Arthur's sister. She's the one who saved her pennies so that she could buy them for him for his birthday. You know, there ain't no words in any language that can truly define the meaning of a wonderful momma...there just ain't no words. Uncle Arthur didn't have those bell-bottom trousers on for five minutes before he started strutting around the house like a rooster with a trick leg. Me and my sisters poked fun at him. "Uncle Arthur, Uncle Arthur," we'd laugh. "You look like you're going to lay an egg."

Uncle Arthur wore the bell-bottom trousers to church that morning. When we came home, Momma fixed us up a real nice lunch. Daddy was over in Tallahassee, taking a stand with the commercial fishermen. Uncle Arthur was making a happy plate, sopping up the last bit of molasses with a buttermilk biscuit, when he said to Momma, "You know Dorothy, it being my birthday and all, I believe I'll go fishing."

Momma looked at Uncle Arthur and advised, "Now Arthur, if you're goin' fishin', you'd better be coming out of those new bell-bottom trousers. You'll likely get them soiled out there."

Uncle Arthur became a little sullen. "Now Dorothy, you know that I don't mean you no disrespect. And you know how much I love these bell-bottom trousers. As a matter of fact, I love these bell-bottoms so much, I ain't gonna take'm off. Now, don't worry Dorothy. Everything is going to be okay. You know those navy boys wear them all the time out there on the water."

Momma just shook her head as Uncle Arthur headed out the door to go fishing. Sure enough, he did catch a nice string of fish and brought them home. Momma said, "Well Arthur, since it's your birthday and all that, I'll fry up these fish for dinner, and if you want to go down to the brier patch, I bet those blackberries are just ripe for the picking. I could make your favorite blackberry cobbler." Oh, a big smile came across Uncle Arthur's lips as he jumped to his feet, ran into the kitchen, grabbed one of Momma's two-quart pots and then headed for the door. Momma hollered

after him, "Now Arthur, before you go down to the brier patch, you'd better be coming out of those new bell-bottom trousers. You're likely to get something snagged on them."

Uncle Arthur looked like a scolded schoolboy. "Now Dorothy," he said, "you know I don't mean you no disrespect, and you know how much I love these new bell-bottoms. Yes Ma'am, I love 'em so much that I believe I'm just gonna leave 'em on. Everything is going to be okay; I ain't gonna get nothing snagged on these fine trousers." Momma just shook her head as Uncle Arthur headed out the door with the two-quart pot in his hand.

The road to the brier patch twisted like a ribbon beneath live oaks, magnolias and long-needle pine trees. It had not rained in a while, and Uncle Arthur was stirring up a little dust as he dragged his feet through the sand. A more beautiful day would be hard to find; the sky was the color of robin's eggs, the light was golden, burning through the leaves, and you could hear Uncle Arthur whistling and singing away like the happy soul that he was.

When Uncle Arthur reached the brier patch, he just couldn't believe his eyes. Everywhere he looked the bushes were covered with giant blackberries, so he went right to work. He'd pop one in his mouth and one in the pot, then two in his mouth and one in the pot. As the sugar from the berries broke across his tongue, it induced Arthur into singing a blackberry song at the top of his lungs: "Blackberry cakes, blackberry pies, I'm gonna make me some blackberry wine."

Now, Uncle Arthur wasn't the only one at the brier patch. Mr. Fox was there; Ms. Bird, Brother Rabbit and Mr. Rattlesnake were all right there. Now, Mr. Rattlesnake wasn't there to eat no berries, no sir. He was hungry, and what he had in mind was meat. He was all coiled up underneath the briers waiting for a nice fat rat to come along. But instead of a rat, here comes Uncle Arthur, just singing away and making a racket, "Blackberry cakes, blackberry pies..." Now, Mr. Rattlesnake figured that possession was nine-tenths of the law. He got to the brier patch first and had staked out this piece of real estate for himself, and he didn't believe that he needed to be sharing it with the likes of Uncle Arthur. So he reared up his head and started shaking his rattle to warn Uncle Arthur that he'd better not come any closer. But Uncle Arthur was singing so loud, and having such a good time, that he never heard Mr. Rattlesnake shaking that rattle. So Uncle Arthur took another step closer. Why, any closer and he would have put his foot right on that serpent.

Now folks, we are all blessed with a sixth sense, an intuition, a warning from some organizing intelligence within us when something dreadful is about to happen. Sure enough, Uncle Arthur stopped singing and looked down at that rattler just as he was about to bite him. The snake uncoiled its power toward Uncle Arthur just as he was leaping straight up into the sky. The snake just missed Uncle Arthur's flesh and buried its fangs deep into those new bell-bottom trousers and got snagged in the material,

so that when Uncle Arthur's feet returned to the earth, he now had a five-foot eastern diamondback attached to those new bell-bottom trousers. Well, when confronted by such a disaster, a man's first instinct is to run. And make no mistake about it, Uncle Arthur started running about twenty miles per hour right off the bat, dragging that snake every step. Why, he ran so fast that he ran right out of his shoes, and blackberries were flying through the air like confetti at one of those big New York ticker tape parades.

We could hear Uncle Arthur coming up the road; he was screaming at the top of his lungs and making a trail like a dirt devil. When we saw him come around the sharp bend in the road, he was running so fast that he was picking up sand with his shoulder. "Dorothy, Dorothy, hep me, hep me!" he was screaming as he ran into the yard and started racing in wide circles. He knew that if he stopped running, that snake might pull loose and bite him.

Momma couldn't believe her eyes; she just shook her head and said, "Now Arthur, I believe you best be coming out of those bell-bottom trousers."

Arthur replied, "Now Dorothy, you know I don't mean to treat you with no disrespect, but how do you suppose that I do that without getting bit by this devil?" Momma instructed Uncle Arthur to unfasten his trousers at the waist and start running down to the pond. She said, "Go to the side of the pond with the high bluff and leap into the air with one of your swan dives. Do it like your life depends on it...'cause it probably does." Uncle Arthur

followed Momma's instructions to the letter. He undid his trousers at the waist, and holding on to the sides of his britches, he headed out toward the pond, still dragging that snake with every step. Momma took off right behind him. Uncle Arthur made it to the high bluff on the north end of the pond, planted both feet on the bank, and sprung into the air with the grace of a giant blue heron. Just as he did, Momma reached down and grabbed that rattlesnake's tail. Well, Uncle Arthur laid out into the prettiest swan dive I believe I ever saw. It surely would have won a gold medal at the Olympics. And just as he laid out, when his body was parallel with the water, Momma pulled back on the tail of the rattlesnake and peeled those bell-bottom trousers right off of Uncle Arthur. Why, she yanked so hard, those trousers went flying past her head. Then she snapped that snake like it was a giant bullwhip, breaking its neck.

Uncle Arthur came out of the water singing praises to his sister and thanks to the good Lord. Uncle Arthur skinned that snake and made momma a pretty belt. He took the buttons (you know, the rattles) and hung them over the rear view mirror in his ol' pick-up truck. And Momma, well, she fried that snake up with the fish for dinner that night. Have you ever eaten rattlesnake? Why it tastes just like…no, not chicken. Whoever told you that? It tastes just like rattlesnake. Momma chuckled, "Now Arthur, we don't have no blackberry cobbler for desert, but if you'll bring me those trousers, I'll sew up that snag."

Uncle Arthur got real quiet. He replied, "You know Dorothy, I don't mean to treat you with no disrespect. And I really do love those bell-bottom trousers. But I made a deal with the Lord that if I ever got those trousers off without getting bit by that snake, I'd never ever wear them again."

So those bell-bottom trousers lay folded up in Uncle Arthur's dresser for many years, and this story has entertained many folks who came calling on us at the old homeplace. Uncle Arthur died not long ago, and just before he did he said to me, "You know son, there ain't no words in any language that can truly describe the meaning of a wonderful momma."

TAILYBONE

A Traditional Story Retold in the Florida Tradition

Ocklawaha is an Indian name that means "twisted waters." If you could fly like an eagle or hawk on thermal air currents high above the Ocklawaha River, you would understand how it got its name. The river snakes its way through the wilderness and has thousands of capillary tributaries. It was on one of these tributaries, many years ago, where an old man lived all alone in a one-room cabin that had a fireplace at the northern end. Each night you could find the old man cooking whatever he had caught or shot that day, and if he didn't have any fish or meat to cook, he would just make himself a big pot of beans.

One night, when the moon was full and the air was crisp from a passing cold front, the old man was in front of the fireplace, cooking himself a big ol' pot of beans. Outside, the night grew darker, and the wind was howling through the treetops. Well, all of a sudden, he heard a noise underneath the floorboards of the cabin. As his eyes scanned across the floor, they came to rest where some kind of animal was trying to come in through a hole in the floorboards. It was a hole that he should have patched a long time ago, but it was too late now; the thing was coming in.

It had a long, pointed snout with big slimy teeth and blood-red eyes that burned with a strange light, and its size

was bigger than a dog. It was like nothing he had ever seen. As the thing started moving closer toward him, he carefully reached down and picked up a hatchet that was resting by the fireplace. Slowly, he raised it over his head, closed his eyes and—bam! He slammed it down on the creature and cut off its tail. Well, it made a hideous scream and went running out the same way it came in.

Now, that old man had lived in those woods for his whole life, and he had never seen anything like that before. Yet, there was its tail, still wriggling on the floor. He reached down and picked it up. It was a big ol' long thing. It didn't have any hair on it, just a few spines. It was quite fleshy, and he didn't have any meat to flavor those beans. So he threw it into the pot and cooked it on down. Then, like a fool, he ate it. Well, it tasted pretty good to him. He ate that whole pot of beans, but when he finished he started to get a stomachache and went to lie down. He crawled into bed, pulled the covers up and was just about to go to sleep when he heard a scratching noise up the side of the cabin. He raised himself up in the bed and said, "Git outta here! Ya hear me? Git."

But what he heard in response was, "Tailybone, tailybone, I want my tailybone."

The old man figured that someone was trying to play a trick on him. "Now, go on and git outta here," he hollered again. "Go home and leave me alone."

But again the voice demanded, "Tailybone, tailybone, I want my tailybone."

Well, the old man called his dogs: "Ino, Uno, come to Old Calico. Get that thing." The dogs ran out from under the cabin and chased the thing deep into the woods. When the old man went to the door, he could hear his dogs barking far into the swamp. He knew that they were mean dogs; he didn't even worry. His mind at ease, he crawled back into bed and went to sleep. But he hadn't been asleep long before a scratching sound woke him. This time it was outside the door. Something was trying to come in. He sat up in bed and cried, "Now, I told you before to git outta here. Just go on now, git!"

But the response was the same as before, "Tailybone, tailybone, I want my tailybone."

Well, the old man called his dogs again: "Ino, Uno, come to Ol' Calico. Get rid of that thing." The dogs almost tore through the fence trying to get at the animal. This time, when the old man went to the door to listen, he could hear the dogs calling "Ururur" far off in the swamp. Then there was an abrupt silence. It concerned the old man, but he figured the dogs had trapped that thing down in a hole and that he couldn't hear them. This time, however, when he closed the door, he locked it. He went to bed and tossed and turned for a long time, but he did finally fall asleep. About midnight he was awakened, not so much by the sound of the wind, but by the message that it carried. He sat up in bed, and drifting to his ears from way down in the woods came "Tailybone, tailybone, I'll get my tailybone."

Well, the old man jumped out of bed. This time he was scared. He called, "Ino, Uno, come to Old Calico. Get that thing!" But all he heard was the sound of the wind. He called his dogs again: "Ino, Uno, come to Old Calico." But he knew that the creature had taken his dogs out into the woods and lost them…or killed them! The old man didn't know what to do. He went around the cabin, closing and barring all the windows. And then he built up a big ol' roaring fire so that nothing could come down the chimney. He barred the front door shut and then remembered the hole where the thing had come in. He stuffed it full with old rags and pulled a heavy chest over the top so nothing could come up through the floor. Still, he couldn't sleep. He picked up the hatchet and began walking around the room, waiting for that thing to come back.

Waiting, listening and pacing all night long made him so tired. He figured that if he could stay awake long enough for the sun to come up, he'd be safe. So he went to the window to look out. He opened the squeaky shutter, and sure enough, the sun was coming up. "Free at last, free at last!" he cried. He felt so good that he closed the shutter and fell into bed. He was pulling the covers over his shoulders when he heard scratching at the foot of the bed. "Tailybone, tailybone, you got my tailybone." The beast pounced onto the ol' man and scratched him to pieces. Some people say that thing finally got its tailybone.

Now, you can go up all of those tributaries off the Ocklawaha, but you won't find that cabin. Oh, you may

find the remnants of the old fireplace. And sometimes, late at night, when the moon is full and the wind is howling through the trees, folks say that you can still hear, "Tailybone, tailybone, I got my tailybone."

A WATER MOCCASIN NAMED FROG

When I see a lot of families packing up their gear to head out toward our beautiful beaches for a day in the sun, I must admit that my first inclination is to head in the opposite direction, you know, inland. Isn't it just amazing that millions of folks from out of state, and out of the country for that matter, have visited Disneyworld and have gone home telling their friends that they have been to Florida. That's outrageous! Until you have swum in one of our springs, hiked through our forest or canoed down our rivers, you have not been to Florida. You have to go inland. My favorite way to spend a day in Florida's inland wilderness is to go over to the Ocklawaha River.

I can put in on that river at any number of locations, but I prefer to drive down to Welaka, cross the St. Johns River and enter the mouth of the Ocklawaha. You know, when I start to paddle my canoe against the river's current, my back gets straighter and I grow a little taller. My senses are awakened by the beauty that surrounds me. I know that I am on an ancient river, a river older than the flow of human blood through human veins. The Ocklawaha is

home to one hundred species of fish, two hundred species of birds and three hundred species of mammals, and it's a river not just filled with water, but with the lives of our ancestors as well.

About two-thirds of the way up toward the Rodman Dam, on the left-hand side of the river, is a little sandy beach area. It makes a great place to camp out, especially when the water level is low. About thirty-five yards above this spot, on a bluff, is an Indian mound. It bears witness to the fact that there were human beings here, on this same spot, twelve thousand years ago. At that time, most of North America was covered with glaciers. To keep from being frozen in glacial ice, all of the animals came to Florida. Florida was a wild place, and the Ocklawaha remembers. The very concept of moving to Florida to get away from the cold began back then.

One night, I decided to camp out on that special place. I pitched my tent, built a nice little campfire and proceeded to make some of Bobachoo Bob's campfire chili. Guaranteed to burn you twice! I fixed a big ol' plate of that chili and opened a bottle of Mescal tequila to help wash it down. You know, that's the one with the worm in it.

Now, my favorite time of day is when the great wash of evening comes over the Ocklawaha, and I can watch the dance of shadow and light. Then that first, bright wandering star, Venus, appears in the sky, followed by all those brightly scattered stars that sparkle and shine just like diamonds. So, I'm sitting in my little camp chair, listening

to the owls hoot, the gators beller and the frogs sing, and staring at the caveman's television. I started to get sleepy, so I went inside my tent, took off all of my clothes, lay down and got ready to drift off to that place where sleep is perfect. All of a sudden I heard a terrible noise that was coming from outside of my tent. Now, I knew I wasn't going to sleep with that racket going on, so I got back up, dressed, fired up my ol' Coleman lantern and followed my ears down to the water's edge. There I saw a huge bullfrog stuck in the mouth of a big water moccasin, and that bullfrog was making a soul-disturbing sound. Now, I'm not the kind of man who would ever mess around with a water moccasin, but this one had that fat bullfrog stuck in his mouth, so I knew he couldn't bite me. I grabbed the snake behind his head and picked him up. That snake didn't like that one bit. He wrapped around my arm and gave me the old evil eye. I took hold of the bullfrog and twisted it one way, and then another, and finally pulled him free.

When a poisonous snake bites, it doesn't always inject venom. Sometimes they do what is called a "dry bite." That must have been the case here, for there was nothing wrong with that bullfrog. As a matter of fact, he was one happy little fellow when I let him go. I said, "See ya, man!" I flashed him a peace sign and turned my thoughts back to the water moccasin. Now, what in the world was I going to do with him? He was all twisted around my arm, showing me his ugly cotton mouth. I couldn't let him go; he'd bite me! And I wouldn't blame him; I'd just deprived him of

his supper. So, I carried him to the campfire, and I started walking around in circles, wondering how I was going to get rid of the snake, when I noticed the bottle of tequila laying on the ground. I picked it up, pulled the cork out with my teeth and took a slash of that tequila. I started to take another slash but stopped to study the bottle of tequila and then ponder the water moccasin. I decided to give him a slash of that tequila. His eyes rolled way back in his head. You know, about thirty seconds after I gave that snake a swallow of the tequila, I could feel him lighten his grip on my arm. So, I gave him another shot; I even gave him the worm. Well, about three minutes after that, I swear to you, that water moccasin was hanging off of my arm like a piece of wilted lettuce. I took him back down to the river bank, extended my arm out over the water and *splash*—I let him go.

Now, I knew that I wasn't going to sleep after that big adrenalin rush. So I threw another log on the fire and sat down in my little camp chair. I was looking up at the bright wondrous stars, listening to the owls hoot, the gators beller and the frogs sing, and I was sipping on that bottle of Mescal tequila. Eventually, I fell asleep right in that chair.

Now, I don't know how long I was asleep before I felt something bumping me on my leg. I opened up my eyes, screamed and jumped straight up in the air. There was that same water moccasin. And he'd brought me another frog! So I picked him up and let the frog go. Then I took the bottle of tequila and poured a few drops over the water

moccasin's head, declaring, "Mr. Water Moccasin, I hereby christen you, 'Frog.'" I gave him a slash of tequila, took him down to the water's edge and let him go. I crawled into my tent and got one of the best night's sleep I've ever had.

Several days later, I was canoeing past that very same spot with a real good friend of mine, and wouldn't you know it,

here came that same water moccasin swimming out toward the canoe. I said, "Hey Gamble, look, it's Frog."

Gamble looked at me a little askance and said, "Now Bob, that's not a frog; that's a water moccasin. You go fooling around with that snake and only one more white shirt will do you. You've got to remember that Florida is a wild place."

THEM OLD-TIME HEALING WAYS

Well, it was just a simple case of "have to!" There weren't no doctors out in the woods back in those days, and besides, ain't nobody had two dollars to pay for one. So when we got sick, we went to Momma. She learned doctoring from her mother, and her from her mother before that. Now, before you start criticizing those old-time healing ways, I'm here to tell you that when Momma treated you, you got better.

It was a beautiful Sunday afternoon. I had spent all morning listening to the preacher orate about the power and glory of God's love and the wickedness of the devil. I decided to spend the afternoon fishing. I wouldn't be lying to you if I told you that I was catching a boat load of bream and shell crackers just using one of those little jigger-bobs. Oh, they was easy to make. Take a hook, a little copper wire and some chicken feathers, dangle that little devil off the end of a cane pole and soon you'd be busier than a set of jumper cables at a poor folk's picnic.

I was having such a good time catching those fish that I failed to recognize that darkness was coming on. I threw that big string of fish up on the bank and started to pull the boat in when I heard a big gator beller. I knew he was close because I could feel the earth tremble and see the water quiver. I was so busy watching for that gator that I never noticed a big ol' panther slide out of the palmetto and hunker down right on that string of fish. When I turned around and saw that I was face to face with a Florida panther, I was scared. I didn't even have a gun. All of a sudden, that gator bellered again, and I turned my thoughts in that direction just in time to see a mammoth, ten-foot gator coming in for that string of fish, too. So, I had a mean panther on one side of me, a hungry gator on the other and figured that things couldn't possibly get worse than this. But I was wrong, because when I looked down at my feet, I saw that I was face to face with an enormous water moccasin. He was all coiled up and showing that ugly cotton mouth.

I raised my eyes to the heavens and cried, "Lord, deliver me from this evil situation, and I will be your faithful servant forever." Just then, the snake struck me above the left knee. It felt like someone hit me full stroke with an axe. I screamed out in agony as I watched that snake coil to strike a second time. Again I cried, "Lord, please! Deliver me from this evil situation, and I will be your faithful servant forever." Well, I thought I was a dead man, when all of a sudden out of a big magnolia tree came a giant horned owl, which swept down on that serpent. Oh, a great battle

ensued. That snake, all tangled in the talons of the owl, struck feverishly at the face of the horned monster. And all of a sudden, that gator bellered again. The panther got up on its hind legs and began to swat and hiss at the gator. I saw it was time to make my escape, so I started running. I turned around to give a quick glance and—bam! I ran right into a live oak tree. I felt the bark peel the flesh from my forehead and the blood flow down the side of my face. I was staggering all the way home.

I fell through the front door. When Momma saw me, she sprang into action. She cut off my trouser leg, and with a long kitchen knife, she carved two incisions across each other, right where that snake broke my skin. With her mouth, she sucked out what venom she could, spitting it all out into the hearth. She cleaned my wound with lamp oil and went out to the front porch, where she gathered spider webs from under the eaves. She came back in and stuffed them into the gashes in my forehead, dabbing them with turpentine. She made a garlic paste and rubbed it all over my chest. She gave me sips of mushroom tea. I came down with a fever, and I hallucinated for two days and two nights. I came face to face with the wickedness of the devil and the power and glory of God's love.

I'm alive today because my Momma gave me my life twice. First when she brought me into this world, and again when she saved me from the venomous fangs of the devil. So the next time you begin to criticize those old-time healing ways, just remember: when Momma treats you, you get better.

THE VANISHED PEOPLE

Those of us who live in lonely places think that we know darkness. Why, I've been to some places where it was so dark that you couldn't even see your hand in front of your eyes. I've been to shadow places that are as black as a water

moccasin's eye. But this story I'd like to tell you now deals with a different kind of darkness, and unlike many stories that you may hear, I can tell you that this one is real. It's about the darkness that fell upon Florida's indigenous people with the arrival of the first Europeans.

We have solid archaeological evidence that there were human beings living here in Florida more than twelve thousand years ago. For thousands of years, these people lived in complete harmony with the land, passing on their culture from generation to generation through stories and songs. There were hundreds of complex societies in every part of the state. But at the end of the last ice age, so much of the Earth's water was frozen in glaciers that the oceans were hundreds of feet shallower than they are today. This means that Florida's land mass was twice as large as it is now. The land was inhabited by wooly mammoths, sloths, camels, saber-toothed tigers and bison.

A tribe of people who occupied the southwest coast of Florida were known as the Calusa. They were hunter-gathers and fisher people. They built towering pyramids out of football-sized whelk shells. They dug holding ponds for fish. They constructed long houses capable of housing thousands of tribespeople. They crafted ceremonial altars that faced the setting sun. Their priests wore wooden, mythological, godlike masks. They practiced human sacrifice, and according to the earliest Spanish missionaries, their kings wore a curious gold medallion on their foreheads. The fact that the Calusa lived here in

such large numbers is amazing considering that there are no traces of any kind of their agriculture. The fact that they thrived here is truly amazing.

On the northeast part of the Florida peninsula there was another great society of Native Americans known as the Timucua. These people farmed in summer and hunted in winter. They would kill alligators by ramming a large pole down their gullets and turning the animals over. Because of the position of the alligator's small brain, it would fall asleep, allowing the Timucua an easy kill. The Timucua lived communally, and their houses were grouped together and surrounded by a stockade fence.

The Timucua were generally peaceful but could be savage warriors, taking the scalps and limbs of their enemies and displaying them on poles. Long before the first Europeans arrived, they possessed an advanced language. They had several words for trust and different words for virtue but had only one word for water—*Ibi*.

Ibi was rainfall, rivers, lakes, swamps, dew and more. It held fish, floated their dugouts and watered their crops; it gave life and took life away. To the Timucua, *Ibi* was sacred. So when the firstborn son of the great chief Saturiwa was born at the water's edge, he named his son Ibi, and like the water, Ibi became a sacred son of the Timucua. When Ibi was fourteen, Saturiwa sent him on a mission to meet the son of a powerful Calusa king, and together the boys were to go out in search of the great Spiritwalker. Ibi took his dugout up the St. Johns River, turned west up the Ocklawaha and

went to where the Silver River blends its crystal waters with the tannin-stained waters of the Ocklawaha to meet the Calusa king's son. There, the two young boys camped together. They ate fresh fish and wildwood fruits, and they made the black drink from the Yaupon holly. They stayed up late into the night talking about their adventure of finding the Spiritwalker. They both fell into a deep sleep, and as the embers from the fire burned down to just a glow, the great Spiritwalker came into their camp and spoke to the boys in their sleep.

He told them that the Sons of Darkness would descend upon their peoples like a plague. Over time, all would perish from the disease and brutality introduced by the hands of people who would be about four inches shorter than them. They were told by the Spiritwalker that these dire times would begin when a large ship, carrying the People from Before the Sunrise, anchored off their coast. Both boys awakened from their deep sleep startled. Just to look at each other was enough to know that they both had received the same message. Each boy headed home in his own dugout, wondering how to tell his father the message delivered by the Spiritwalker.

And then it happened, somewhere around Mosquito Inlet, in 1513: the first great ship appeared on the horizon. Ponce de Leon anchored off of the coast and marveled at this new land that he would claim for Spain. He called it La Florida, because it was Easter, the festival of flowers. With this one event, according to the Spiritwalker, time

would begin ticking down for Florida's Indians. It was the beginning of the end for these people who had lived here for more than twelve thousand years. Ponce de Leon sailed around the peninsula to Florida's west coast, and there he encountered the Calusa, who had been tipped off by the son of the Calusa king. The Calusa fought with bows and arrows from their canoes. Arrows rained from the sky onto Ponce de Leon's men. Ponce de Leon himself eventually died from wounds inflicted by the Calusa arrows.

The Calusa thought they were safe until more ships arrived on the west coast, led by Navarez, in 1528. Navarez was renowned as a great conquistador. He was known for the cruelty that he had inflicted on native people during his conquest of Cuba. He stole food from the Calusa and took them as hostages. After a mere five months of warring against the Calusa, what was left of Navarez's army made rafts and floated off into oblivion. Only four survivors made it to Mexico.

Tales that Florida had many riches continued to make their way back to Spain, so the monarchs sent another conquistador, Hernando de Soto. De Soto had made his fame and fortune looting and slaving in Central America. In 1539, his massive expedition anchored off of Longboat Key. He unloaded more than seven hundred people, more than two hundred horses and bull mastiff attack dogs. Uncooperative Indians were thrown to the dogs, or worse, their limbs were cut off and they were wrapped in straw and burned alive.

De Soto had enough food and supplies for only eighteen months, but 4 years later, those who survived had nothing but the rags on their backs, and they left behind everything that they brought, including de Soto. The Indians never forgot how wicked and cruel de Soto had been. For though they survived the initial attacks from Spain's invaders, they could not fight the onslaught of diseases that the Spanish brought to their shores. All of the sons and daughters of the great Calusa kings and Timucuan chiefs would perish along with the Apalatchee, the Tequista, the Tocobaga, the Matecombe, the Ais, the Jororo, the Hobe, the Potano, the Ocali and the Alachua. What the great Spiritwalker had predicted came to pass. After 250 years of occupation by the People from Beyond the Sunrise, there is no trace of any of Florida's indigenous population in the gene pool. How could so many people vanish? I wonder, "Where have they gone?" I wonder, "Why are they not here?"

THE GIFT

When you play music for a living, the most common question people will ask you is, "Hey, what do you do in real life?" Now, if you tell folks that you are a storyteller, the most common question will be, "Where did you learn storytelling?" I make no bones about it. Though I've played in barrooms all over this country for forty years and have met many storytellers and heard their stories, for me, I'd

have to say that I learned storytelling from my dad. Now, don't get me wrong; Dad wasn't the kind of man to sit down and tell you traditional stories. His stories were about life, and he made them up as he went along.

My father was a drill sergeant in the U.S. Marine Corps. He was involved in a freak accident in which a jeep ran over both of his feet. Ever since that accident, my father had extremely wide feet. He could never find shoes wide enough to fit, and even when he wore triple Es, he would still walk around with his shoelaces untied because that was the most comfortable for him. One day, he was taking a walk with his granddaughter when she looked down at his feet and said, "Grandpa, we can't go for a walk until you tie your shoelaces. You're likely to trip and fall."

My father got that serious look on his face and replied, "Now, Kathleen, I'm not allowed to tie those shoelaces because I'm a member of the CIA, and that's how I get my messages—through those shoelaces!" And because he was Grandpa, patriarch of the family, of course she believed him. Besides, dispelling any doubt, Dad would stop halfway down the street to rest his sore feet by saying, "Oops, Kathleen, quiet. I'm getting a message. It's the president and Lady Bird. They want me to come to Washington for dinner." Little Kathleen's eyes would get as big as silver dollars; she looked at her grandfather like he was the most important Gramps in the whole wide world.

I recall one Father's Day when I was trying desperately to come up with a nice gift. Dad still had all the ties,

socks and handkerchiefs I had given him over the years in his dresser drawer. He did drink the bourbon I gave him. I thought, "I'm a songwriter; why don't I just write my dad a nice Father's Day song?" So I did, but never in my wildest imagination did I think the gift would be so well received. My father had the lyrics reproduced in calligraphy, and he hung them up in his bedroom. He purchased a little portable cassette recorder and played the song over and over. God forbid if one of the neighbors would come by. He'd say, "Hey, listen to this song my son wrote just for me."

As fate would have it, soon after that my father had a stroke that took away most of his hearing. And because hearing affects balance, my dad started to fall a lot. It wasn't long before he fell and broke his hip. We got him through the hip surgery and he was making a great comeback when he had a heart attack. Now, my father was not afraid of man or beast, but his great fear in life was that he would die alone in a nursing home or a hospital. So, the family gathered together and signed Dad out of the hospital and bought him home to his own bed. That seemed to please him greatly.

I slept outside of his room on the couch. That first night home, about three or four o'clock in the morning, I woke up when I heard my dad crying out, "Bob, Bob!"

I jumped up, went running into his room and said, "Dad, what's the matter?"

My dad looked all around the room and said, "Son, who are these people in here? What are they doing here?"

I looked all around the room and replied, "Dad, there's no one here. It's just you and me. Everything is going to be okay." My father went back to sleep.

The next night, again about three or four o'clock in the morning, I heard my dad cry out, "Bob, Bob!"

I jumped up, went running into his room and asked, "Dad, Dad, what's the matter?"

Again, my father was looking all around the room and said, "Son, who are all these people? I don't know them. What are they doing here? Get rid of them for me, will you, Son?"

I looked all around the room before I reassured him, "Dad, there's no one here. It's just you and me. Everything is going to be okay." My dad went back to sleep. Shortly after that my father slipped into a coma and was slowly swept away. He was eighty-nine.

We put the homeplace up for sale and took Mom home to live with us. It took about three months to sell my parents' house. We all had to go back down to empty the place out. Years and years of memories were tucked away in all of the corners of the house. It was hard work, and I was dead tired. I spent the last night in my father's house sleeping in his bed. You know, about three or four o'clock in the morning, I woke up shivering and shaking. When I opened my eyes, I was astonished to find that the room was filled with the likes of people that I had never seen. The only way I can describe them is that they all seemed to have an "afterlife" expression on their faces. I was so startled that I reverted back to my childhood. I cried out, "Dad, Dad!" Then, in the corner of the room, I saw my father walking through that crowd of people. He walked up next to the bed. I said, "Dad, who are these people? What are they doing here?"

My dad looked all around the room and then down at me, and he smiled: "There's no one here, my son. It's just you and me. Everything is going to be okay."

OSCEOLA

I live in an area of town called St. Augustine South. It stretches along the west side of the Intracoastal Waterway. I live in the south end of the development, which has lots of large, beautiful trees. My home is buried beneath giant live oaks in which a family of barred owls has been living for years. We have twenty-eight varieties of oak tree in this part of Florida. Sure, when the Spanish came here they were interested in gold and silver, but they were also looking at those oak trees for the shipbuilding trade.

My neighborhood is bordered on its southern end by Moultrie Creek. Now, this is a very picturesque creek, and if you canoe way back up into it, you will come to a high bluff. If you climb up that bluff and walk through the woods you'll come across a historical marker for the first time in Florida, indicating that a flag of truce was ignored under the orders of an officer of the U.S. Army.

It was close to the end of the Seminole Indian wars, and make no doubt about it, the people of Florida wanted the Indians removed or exterminated. Major General Thomas J. Jesup, who commanded the largest concentration of troops in the United States, was sent to Florida to move the Indians to Arkansas.

Chief Osceola was camped out along Moultrie Creek with about one hundred braves. They were coming to St. Augustine to secure the release of Chief Osceola's friend, King Philip. General Jesup released King Philip's son,

Coacoochee, and told him to tell Chief Osceola that he could come to St. Augustine and that he would be treated with respect. Chief Osceola, as a gesture of good faith, sent in more than seventy runaway slaves.

So, on a beautiful morning alongside Moultrie Creek, Chief Osceola gathered his braves and began the trip into St. Augustine waving a white flag of truce. They were ambushed and captured by soldiers led by Lieutenant Peyton and imprisoned. A year later, Chief Osceola died in Fort Moultrie. Osceola's story led newspapers throughout the country, many leading citizens and even men who had fought against the Seminoles to protest against the dishonorable tactics of Major General Jesup.

In many native cultures around the world, it is believed that during times of great stress you can send your spirit to another place. Amongst the Seminoles, it was believed that Chief Osceola was so distressed by the dishonor of the white man that his spirit left him out there on Moultrie Creek and that General Jesup got only his body. It had been reported many times that Chief Osceola's body sat lifeless in the Castillo De San Marcos until he died a year later in Fort Moultrie. It was widely believed amongst Chief Osceola's people that his spirit still roamed free…out there on Moultrie Creek.

MY NEIGHBOR BOB

As a younger man, I used to like to stay up late and hoot with the owls. When most folks were getting up to go to work in the morning, I'd be in deep and perfect sleep. Not too much would ever disturb me in that state. But one morning, I was startled out of my sleep by the sound of gunshots coming from the front of my house. Reacting like a typical veteran, I slid out of bed onto the floor, crawled on my belly across the floor over to the window sill and cautiously peered out of my window. The street appeared quiet; all I could see was my neighbor from across the street—Ol' Bob, sitting in one of his handmade rocking chairs and reading a newspaper like nothing had happened. I started to question my own sanity, but when I looked again at my old neighbor I saw the butt end of a rifle sticking out beneath that newspaper. I watched him for a little while, until he dropped the newspaper and looked up and down the street. When he saw that the coast was clear, he rose up out of that rocking chair with the rifle in his hand, went over beneath his pecan tree and picked up two dead squirrels. I later found out that he called them "tree rabbits." He skinned the squirrels, cleaned them, cooked them in a cast-iron pan, covered them with delicious brown gravy and ate them for dinner. That pecan tree was very special to Bob because it could produce both Stuarts and Mahons due to successful grafts, and he didn't want any squirrels, or tourists for that matter, to be stealing them.

Every Christmas, Ol' Bob would distribute those nuts to his special friends as gifts.

I lived right behind the Old Sugar Mill north of the city at the time. My house was a classic "cracker" design with a shotgun living room. It had a giant live oak tree right outside of the screened front porch. Bob's house sat diagonally across from mine. Many years ago, when Bob built his house with the help of his two sons, the area was just an orange grove. His house was built with great skill and love. He trimmed it out in cypress and gave it beautiful heart of pine floors. Ol' Bob carried the burden of outliving his two sons. One died of cancer and the other one to another form of indignant death. His property was a corner lot that he managed like it was a farm. He had orange and grapefruit trees, and he grew pole beans and datil peppers. Motels and neighbors were encroaching, but he held his ground. He had an old Nash Rambler that he could disassemble and put back together again in a couple of hours. Ol' Bob never gave himself to idleness. He had all the spryness, vim and vigor of a young man.

He really was a jack-of-all-trades, but he seemed to derive the most joy from baking the finest carrot cakes in the entire world for my little daughter, Dawn. Bob was Dawn's first introduction to the elderly, and from that point on in her life she thought that old folks were just fine. She would like to play out on the front porch so that she could see Ol' Bob working in his yard. She'd always be calling on him, too. Not a day would pass without a trip across the street to Uncle

Bob's house, where she would crawl up on a wooden chair at the kitchen table to meet a slice of that carrot cake that would be waiting. That old man knew as much about capturing the heart of a little girl as she did about capturing the heart of an old man. Bob was no stranger to my house either. He was always stopping by to say hello or lend a helping hand, but I suspect he came over mostly to see Dawn.

It was opportunity that took me away from that wonderful north city homeplace. I knew that I would miss the daily contact with such a unique person as Bob. I guess I rationalized it in my mind that I could always come and visit with him. But opportunity took me pretty far, and the days drifted into months and then years, and in the blink of an eye my little girl grew into a young woman.

I felt a rush of excitement as I rode into town that day after being gone for so long. I turned down the street to the old homestead and was startled to find that my house had been replaced with a garage. I pulled right up in front of Bob's house, anxious to grab his strong hand in friendship. Everything was just as I remembered it, all neat and trim. The Nash Rambler was still parked in its exact place. The old pecan tree was just beginning to bloom. I walked across the stone porch, past the beautiful handmade rocking chairs, and knocked on the cypress door. An elderly woman, a stranger to the house, answered my knocking. She apologized with kindness. Ol' Bob had just been buried the day before.

GAMBLE ROGERS

The world is full of mysteries. Doesn't it sometimes seem like all of the really good folks in your life have already crossed over? My whole life I've heard folks say, "Only the good die young." My old friend Gamble is an example. It's not that he was that young, mid-fifties, but he sure was good. Gamble was the son of a prominent Florida architect and grew up with a passion for the natural beauty of Florida. He was the best darn finger-style guitar picker around, and he was a very warm and funny storyteller. He created the mythological Ocklawaha County, Florida, and filled it with wonderful and endearing characters. In fact, he was so well known for his stories and performances that he was considered by many to be one of the state's finest ambassadors. He was on his way to becoming a national treasure. But what happened on that October day in 1991 changed the Florida folk community forever.

A wicked nor'easter was blowing that day. The wind was whipping so hard that you'd swear it had blown away the sun. Clouds were hanging a dark and heavy Payne's gray. The ocean churned and boiled like the inside of a washing machine. Riptides and currents were daring anyone to set foot into the waves. As unlikely as it might seem, a visiting tourist from Canada entered those treacherous waters, and before long he was drowning and being swept away.

Gamble was on that sandy shore at Flagler Beach with his wife Nancy and some friends. They were camped at

the state park to enjoy some of Florida's natural beauty. With her hair blowing in the wind and fear churning in her heart, a young girl ran up to Gamble, pointed at her father struggling against the ocean and begged for his help. Now, Gamble Rogers had already gone through a good portion of his life, and I had been his friend for many of those years. I can tell you that he never once turned down an opportunity to help anybody. He listened to all people. He certainly wasn't going to say "no" to that young girl, although I bet you might have. Gamble removed his wallet from his hip pocket and threw it in the sand as if he knew he would no longer need it. He removed his trousers, grabbed an air mattress and headed for the water. Throughout his life, Gamble showed immense compassion for other human beings, and he left this world holding out his hand to help. Sadly, both men perished.

In recognition of his great sacrifice, the City of St. Augustine awarded Gamble the D'Avilles Award—the highest award granted to a citizen. St. Johns County named a middle school after him. The State of Florida named a state park after him, and in 1998 he was inducted into the Florida Artists Hall of Fame. Each year, on the first full weekend in May, musicians and storytellers from all over the country gather in St. Augustine for the Gamble Rogers Folk Festival. It has become one of St. Johns County's premier events. For more information on this musical tribute to Florida's greatest troubadour, please visit www.gamblerogersfest.org.

WILL MCLEAN

I first befriended Florida's Black Hat Troubadour, Will McLean, in the late 1960s. Like so many folks I met in those days, we were introduced in a barroom. The Trade Winds Tropical Saloon in St. Augustine was a mecca for singers, songwriters and folk musicians in those days. I must admit that when I first met Will, even though I recognized that he was a special human being, I had no idea that someday he would wind up in the Florida Artists Hall of Fame. That's no easy accomplishment for a folk singer!

Will was born in the Florida Panhandle, near the little town of Chipley, in 1919. That part of Florida can boast about natural wonders like the Florida Caverns, Falling

Waters and the Chipola River. What about kudzu? Yup! The Panhandle is where the fast-growing vine was developed for three decades. It's all over the South now. I expect to see a horror film someday about New York City being swallowed by kudzu vines.

As a young boy, Will's thoughts were mostly on wilderness. I suppose it was this connection to nature that inspired Will to start writing songs at an early age.

He had a grandfather who encouraged him. From these humble beginnings, Will grew up to become known as the "Father of Florida Folk," writing over one thousand songs and stories about Florida. He performed those songs and stories all over the state and was even presented in concert at Carnegie Hall in New York City. He was awarded a Florida Folk Heritage Award in 1989 and was voted into the Florida Artists Hall of Fame in 1996.

Will still had most of his good health in the late 1960s when he would often visit with me in my home in St. Augustine. He would always arrive early in the day. He was a sweet man to me and my family, although others claim that he had an ornery streak. He spent most of his time drinking and telling stories about Florida. One evening Gamble, Will and myself were all sitting in the living room sharing songs in a round robin fashion that we had written. I had just finished one of my "oh baby, oh baby" kind of songs, and Will commented, "Bob, that was a beautifully written song. Why don't you write songs like that about Florida?" It wasn't long after that I wrote my first Florida song, "The Old House by the Sea."

When it came to drinking and staying up late, in those days I could keep up with the best of them. However, I was no match for Will McLean. He was always the last man standing. When I would get up the next morning, Will would always be gone. Spread around the house, my wife and I would find fresh-cut flowers that he had picked from gardens around the neighborhood in the wee hours of the

dawn. I guess it was Will's way of saying "thank you" for the hospitality.

It's not easy to write a good folk song or tell a good folk story. This art has to feel like it was grown from the earth. It's about the people and the land. Will's song, "Hold Back the Waters," about the great hurricane of 1928 that blew all the water out of Lake Okeechobee onto the surrounding countryside, is still sung at all the Florida festivals. "Tate's Hell" is a story about a man who gets snake-bit and wanders through the swamp trying to escape death. It's a story about life. The song "Osceola" confronts us with our history. "Acrefoot Johnson" heralds one of our folk heroes. The legendary Pete Seeger once declared, "His songs will be sung as long as there is a Florida."

Will McLean spoke to us about all of the things that were Florida, and the message behind his efforts was to preserve these meaningful things for generations to come. Secretary of State George Firestone said in 1987, "I would really like every Floridian to listen to his music. It would tell them important things about Florida that they're never going to learn in the newspaper or on television." Will died in 1990.

The Will McLean Foundation was founded to promote the works of Will McLean and other Florida artists. It provides research, education, performance and training to promote understanding and appreciation of works by Florida artists. Each year the foundation presents the Will McLean Festival in Dunnellon at the Withlacoochee

Campgrounds. It's been going on now for twenty years and is held each spring. It's a place where you can hear the best of Florida's original folk music. www.willmclean.com.

OUT ON THE RIVER

There are large blue asters growing wild on the banks of the Ocklawaha River. They bloom in great profusion in between a maze of giant cypress knees along the water's edge. The images mirrored in the water resemble a kaleidoscope. The trees and cypress knees look like totem poles in the reflections.

I have to snicker when I hear folks say that we have no color changes with the seasons here in Florida. In the spring, you'll see a thousand shades of green, and in the fall, it all changes to crimson and burnt sienna. The cypresses reach high into the turquoise sky, like giant bonsai trees draped with Spanish moss and air plants. Flocks of ibis can white out the heavens. Great blue herons squawk in protest of your intrusion. Ospreys communicate in their shrill tongue, and a kingfisher perches alone. The anhinga drapes its wings. Turkey buzzards wait, bass and bream swirl the water and eagles fly. What a place this is. Water moccasins bask in the sun, while gators—pristine specimens, from little guys to some as large as your boat—watch from camouflaged blinds. Otters as big as dogs frolic in the tannic waters, and turtles, too numerous to count, compete for a place in the sun.

It's easy to make the connection between art and nature in this special isolation. This river's lullaby speaks to us about vanished people living here in enormous, complex societies thousands of years ago. In the voice of wings and leaves, roots and claws, it sings, sighs and shouts. It is no wonder that the ashes of Florida's Black Hat Troubadour, Will McLean, were cast upon these waters, older than recorded time. Here, in the indefinable something that hangs from a tree, in the wind sloshing through dry stalks, in the quiet flow of the water, the spirit of Will McLean has found eternity. I find my life being shaped by the hours that I spend with him out on the river.

GUY BRADLEY

Fillymingo? I'd never heard of such a place, and I'd been all over Florida. When I broke out my Florida map, I looked east, west, north, south and couldn't find any Fillymingo. Sounded to me like the name of a place that you find at the end of the earth. That's when it struck me—"end of the earth." So I broke out that Florida map once again and peered south, way down to the end of the earth, you know, where the land ends and the sea begins. There I found the little town of Flamingo, or, as I later found out, the old-timers used to call it by its Jamaican name, Fillymingo.

Flamingo is on the southern tip of Cape Sable, just below Whitewater Bay. Once you are there, there is no place else

to go. One of the things you realize when you look at a map of this area is that there are very few roads and only a handful of little towns, because you are in the Florida wilderness. Big Cypress Swamp, the Everglades, 10,000 Islands and the Fakahatchee Strand are all places located mostly within Monroe County.

This area is rife with stories, beginning with those of the area's first residents, the Calusa Indians. The Calusa were hunters, gatherers and fishermen, and they had occupied this wilderness for hundreds of years. They built holding ponds for fish, long houses capable of housing hundreds of tribesmen and ceremonial altars, and according to the first Spanish explorers, they performed human sacrifices. The Calusa were followed by the Seminoles, who were descendants of the Creek Indian Nation. The Seminoles found safety and solace in their Big Cypress home. Out of this same wilderness comes the tale of a real Florida Everglades hero: Guy Bradley.

It was during the turn of the last century, early 1900s, when plume hunters would go out into the Everglades wilderness to shoot birds by the thousands for their beautiful feathers. The plumage would then be sold to manufacturers of women's hats. Back in those days, an ounce of those feathers paid more than an ounce of gold. Those high prices caused the slaughter of millions of birds. It disgusted many an outdoorsman and conservationist, and in 1901 the State of Florida finally outlawed the practice. Still, without someone to enforce the law, it would be useless.

The Audubon Society hired Monroe County deputy Guy Bradley to guard the birds. His territory was immense. Not only did he have the Everglades and Big Cypress Swamp, but he also had the Florida Keys and 10,000 Islands. Despite its size, Guy knew the territory well and had acquired great knowledge about the life of those birds. Guy lived in Flamingo, right on Florida Bay, with his wife and two small boys. Though most of the folks who lived in Flamingo had dubious backgrounds, Guy was known as a gentleman who took an interest in his church.

Guy Bradley traveled back and forth across his territory in a small sailboat. He educated farmers, loaners and fishermen about the new law, and occasionally he even made an arrest, which was no easy thing to do when the person being arrested is carrying a gun. Nevertheless, Guy was true to his cause, and consequently some of the rookeries were beginning to show signs of coming back. Things were going well for Guy except for one man and his son who refused to stop plume hunting. Guy had already arrested Captain Walt Smith's son, Tom, a couple of times, and Captain Smith was becoming more and more agitated by Guy's efforts. Under the punishing July sun in 1905, Guy heard shots not far from where he lived. He looked out his window to see Smith's boat just off Oyster Key. He picked up his pistol, kissed his wife goodbye, hugged his sons and rowed out to confront the lawbreakers. Smith warned Guy not to come aboard, and when he ignored the captain's threats, Captain Smith fired a deadly round

from his Winchester into the body of Guy Bradley. Guy's body was found adrift in his boat off the little island that is now known as Bradley Key. Guy Bradley, a pioneer in the cause of protecting wildlife, was the first game warden to die in the line of duty. He left behind his wife and two sons, who were too young to realize the loss of their father. He was buried on Shell Ridge at Cape Sable overlooking Florida Bay. Sadly, the grave was eventually washed away in a storm. There is a monument honoring Guy Bradley in Flamingo; however, his greatest legacy remains with us today, as his murder further aroused public sentiment to pass more laws protecting the birds.

So, the next time someone asks you if you know anything about Fillymingo, tell them, "Sure do; let me tell you a story about Guy Bradley."

The Flower Man

If you travel west, out of St. Augustine on Route 207, you'll eventually come to the little hamlet of Spuds, and a bit farther down the road is the potato capital of Florida, the little town of Hastings. Just on the west side of town is the county line, which divides St. Johns and Putnam Counties. Right there on that county line, on the bend in the road, there used to be a sign that read "Fresh Cut Flowers." I had been stopping there for years to see Mr. Hubert Odum, a friendly ol' cracker of a gentleman, who always seemed

happy to have my business. It was no secret to folks in these parts that his prices were the best around. But besides the good prices, I suspect it was Mr. Odum who brought people in. He was a warm, friendly old man who no doubt had some health issues. It was getting a little scary to stop by now, because Mr. Odum needed oxygen to get along.

As I drove into the driveway, I could see the industrial-sized green oxygen tank, with about forty feet of clear tubing that slithered across the ground and eventually snaked its way up Mr. Odum's back, wrapped around his neck and like a giant cobra sent two polyethylene fangs up his nose. In the corner of his mouth hung a lit cigarette. "Howdy, howdy, Son. What can I git ya t'day?"

"How about a fire extinguisher," I said, eyeing the cigarette. "And I'll take some of those carnations. Now, Mr. Odum, you know you should not be smoking when you're hooked up to that oxygen. If the tank blows up, you'll burn from the inside out."

He replied, "Son, I'm an old man. I'm already burned from the inside out." He flipped his cigarette at the oxygen canister in defiance. "Oh, you should have been here last night. Why, they was a singing so beautiful. Acapulco! There ain't nothing like human voices raised in harmony, you know?" Mr. Odum was looking across the road at the old, black cemetery next to the railroad tracks. It seems to have been a tradition in Florida to bury the dead near the tracks. The railroad owns forty feet on both sides of the track, and it granted permission for poor folks to be buried

there. "Some nights there ain't nothing at all, other nights it's just a whisper, but last night they was a singing in full chorus. Why, it was so loud, traffic was slowing down, folks a rubbernecking, trying to figure out what fool had his radio turned up so loud. My doctor didn't believe me when I told him; he gave me a consultation to see one of those loony doctors. That doctor didn't believe me either, but he came out one evening anyhow. I was sure glad he did. I thought that they was getting ready to send me up to that state hospital in Macclenny. But I ain't going nowhere now, no sir. That

loony doctor says he ain't never heard anything so beautiful as that in his whole life. It was like angels were singing. He had his tape recorder with him and taped the whole thing. But when he played the tape there wasn't nothin' on it. He told me not to tell anybody about the tape."

Now, I've been by the cemetery many times, and I admit that I've never personally heard those voices singing. But I have seen the truth in the eyes of a wonderful old man. I know that it is just a matter of time. Someday I'll be driving by, and I'll hear the sound of a black spiritual rising out of the headstones, tall grass and darkness of that cemetery next to the tracks. And, if I'm really lucky, I'll see Mr. Odum again somewhere, the flower man on the county line.

ROSEWOOD

"January 1923, nine miles east of Cedar Key…"

The lyrics rolled off the lips of my old friend, Steve Blackwell, as he stood on stage in front of a large crowd singing to an audience of ardent listeners. "A town once stood so proud and free. Was a black sawmilling community." The words of truth darted through the nighttime air, confronting us with a dark reminder of our history when an entire town, as the song goes, was destroyed by a lie. I was at the Florida Folk Festival in White Springs amongst a large crowd and could not help but notice an elderly black woman in a wheelchair not far from where I was standing.

She was old, gray and full of sleep, and her face was etched with deep wrinkles, but those tired eyes burned a bright light and seemed to beckon me to her side. Little did I know that she had lived the words to my friend's song. She later told me that Rosewood was a little town filled with "delicious chuckling and laughter" at a time when hurt and insult were common in most black communities. Florida had already developed a history of racial injustices. She told me that Rosewood had its own churches and schools and that most everyone had a job. The Seaboard Air Line Railway came through the center of town.

Steve's song went on to point out that not far from Rosewood was the small white community of Sumner, where Fanny Taylor lived with her husband and two children in a little white cracker-style house with a picket fence. Her husband's job required him to leave early in the morning. Community rumor suggested that while her husband was away she entertained a lover. As the story goes, one day a lover's quarrel turned to violence, and Fanny's face was bruised. Fearing her husband's retribution, she could not tell him the truth of her affair. So she told a lie. She said that she was attacked by Jesse Hunter, a black man from Rosewood. Tragedy sometimes exhibits itself at the most unexpected times and under unwanted circumstance.

"For two days' time the flames burned cruel, burning churches, homes and schools. Men were hanged from their own trees, unmentionable atrocities." Steve's song was

burning a hole in my heart. It was as if I could see the Klan running over the community with their guns and torches. I could hear the screams of the women and children. I could visualize them hiding in the nearby swamp while the mob was stealing all the cattle and chickens. "The devil had himself some fun with the knife, torch and gun. Hell on earth it came to be for this community once so proud and free."

I asked the old woman if she held a hatred for those who committed such terrible offences. She paused for a moment, smiled and said, "No." When I asked her why not, she replied, "Well, I guess, I was cured of my hatred because I outlived them."

No one ever returned to Rosewood, and no one was held responsible for the crimes committed. Now all that remains is a Florida Heritage Landmark roadside marker. The cast-aluminum sign memorializes those who lost their lives and those whose lives were forever changed by the racially motivated violence that decimated the town. There was a movie made about Rosewood in 1977, but it was made in another part of Florida out of fear. Men of all colors and races face the tragedy of life. What happened in Rosewood was a tragedy of American democracy.

BILLY, THE OCKLAWAHA VALLEY RAILROAD GOAT

The Ocklawaha River is one of Florida's most historic and beautiful rivers, and it is the largest tributary of the

St. Johns River. It's one of few rivers in North America that flows from south to north. If you have ever canoed down the Ocklawaha, from Silver Springs down past Gore's Landing and then down to Eureka, you must admit that, being surrounded by so much wilderness, it is hard to imagine that there was at one time a railroad that ran alongside of it. But, not far from it, there was. The Ocklawaha Valley Railroad operated from Palatka to Silver Springs in the early 1900s. You may recall seeing an old Florida postcard showing Silver Springs Depot with a train station on one side and a riverboat wharf on the other. That's actually the spot from which the glass-bottom boats are launched today. Human beings have flocked to Silver Springs for centuries. In the 1500s, the Timucua Indians made this timeless oasis their home of unparalleled beauty. The water was 99.8 percent pure artesian spring water. Roads were very poor back then, so travel by rail or steamship was the best way to go.

There was already a railway line to Silver Springs from Ocala. It was part of the Seaboard Air Line Railway. Besides the springs at Silver Springs, there was a large lumber company owned by Mr. E.P. Rentz. It was Mr. Rentz who constructed another line northward alongside the river up to Fort McCoy and eventually to Palatka. It went bankrupt and was reorganized under Mr. H.S. Cummings of Rodman. The Rodman Lumber Company operated a company town of about four hundred residents. It was a huge mill that made tool handles for industry in the United

States. It was Mr. Cummings who renamed the railway line the Ocklawaha Valley Railroad. Before long he had christened deluxe passenger coaches and an observation car to run from Silver Springs to Palatka.

At the same time, the New South Farm and Home Company owned almost a quarter of a million acres along the railway, and it set about creating colonies, towns and villages. It was at this time that Mr. Cummings was made aware of Florida's first rail fan. As the story goes, Bob (Ocklawaha Valley) Mann states that a tiny billy goat had come to Fort McCoy with the family of one of the engineers. It was a pet belonging to the daughter of the head engineer. On the first day in his new home, the goat heard the train whistle, frantically chewed through the rope that tethered him to his new home and ran to the depot. The train crew was amazed to find the goat in one of the coaches headed for Orange Springs. They put "Billy" off of the train at the next stop with instructions to put him on the next train back home. But Billy did the same thing the next day and the day after that. No cage or rope would hold him when he heard that train whistle. Billy developed a knack for boarding the outbound train and reboarding a train for home. All of the crews kept a sharp eye out for Billy as he traveled his favorite railway. He became a legend. When Mr. Cummings heard of the goat's train travels, he saw the opportunity for a good public relations ploy. He gave all the settlers along the line their own little "Billy, the Ocklawaha Valley Railroad Goat." Many still believe that there may

be goats that are related to Billy in Putnam and Marion Counties to this day.

Mr. Cummings eventually became ill and lost interest in the railway. His company closed, and the railway was sold at a bankruptcy auction. Even though major railway lines bid for the Ocklawaha Valley Railroad, it was eventually declared abandoned by the Railroad Commission. Bob Mann recently told me a story:

A friend named Mitch and myself took it upon ourselves to hike from Burbank, Florida, northward on the old grade to the site of Daisy, Florida, which is deep in the woods today. We followed the right of way, which was clear for a while but then became a tangle of vines, bugs and thorns. After hacking our way through, we entered a primeval forest that was fairly clear of undergrowth. The grade was high and the ground black swamp peat was dry but spread as far as we could see under the trees. When we reached the Daisy Creek trestle, we heard something walking out in the dry cypress knees almost out of sight due to trees. We watched and, to this day, I swear we saw a billy goat! I wanted to go after it, but Mitch wanted to run away. We did neither, and Mitch has teased me about the "ghost goat" ever since. Funny thing is, I had the old timetable from the Official Railway Guide, and best we could figure, it was right at the train time that our goat made his appearance and exit. How funny is that?

MA BARKER

She may have been baptized Arizona Donnie Clark, but to her friends she was just known as Kate. She married George Barker in the early 1900s out in the Midwest. Kate had four sons with George. As it turned out, those boys were just too much to handle, first becoming juvenile delinquents and

then maturing into full-blown criminals. To make matters worse, her husband George was reportedly a drunk. Kate dumped him and joined her boys and their friends, probably figuring that since she couldn't fight them she might as well join them. They became known as Ma Barker and the Gang. They embarked on a crime spree that ran from Minnesota to Texas from the mid-1920s through the mid-1930s. Some have reported that as matriarch of the family Kate directed kidnappings, payroll heists and bank robberies. Others claim that she was simply an accessory to those crimes. Either way, Ma Barker and the Gang left many dead police officers in their wake.

One day, the gang decided to take a vacation from their routine of stealing, killing and hiding. It was very cold in the Midwest at that time, and there was really only one place to visit and get warm—Florida. They had plenty of money when they climbed aboard a steamship in Jacksonville and began traveling up the St. Johns River. They hung a right turn onto the Ocklawaha River and cruised past Silver Springs toward Lake Weir and the little town of Ocklawaha, where they rented a two-story building. It's been said that in this setting Ma Barker and the boys spent their time drinking, playing cards and fighting amongst themselves. One of the local businessmen claimed that "with all the booze they drank, and the food they ate, they were a boon to the local economy." They thought they were safe in this land of warm sunshine and alligators, but one day in January 1935, their vacation came to an end.

The Federal Bureau of Investigation completely surrounded the house with a large number of police officers. Little did they know that most of the gang was in Ocala at that time. Only Ma and her son Fred were in the house. All of the agents aimed their weapons at the house and waited for the signal from the lead officer to begin firing. When the signal was given, all opened fire with everything they had—machine guns, shotguns and handguns. The bullets tore through the exterior wooden structure, reducing it to splinters. There wasn't a wall left that didn't look like Swiss cheese. Everything was riddled from machine gun rounds. The nonstop gunfire had caused the house to be covered with shards of debris and glass. In the midst of it all were Ma and Fred firing right back. Nothing could be heard above the horrific sound of gunfire. Someone reported that most of the FBI agents had prepared by wearing earplugs. I suppose the strategy was to keep a steady barrage of gunfire on the house until it was determined that no one could possibly be alive. It was as if they were trying to kill the house itself.

Finally, the lead FBI agent waved his hand to signal cease firing. A deafening silence followed; the landscape was frozen in time. Ma Barker and her son Fred were dead, riddled with bullet holes, as they lay amidst the debris of the house. Everything in the house was completely destroyed except, by some miracle, a chandelier that didn't have a mark on it. Ma Barker and Fred were put on display like hunting trophies. Their bodies were full of bullet holes.

The nearby community of Lake Weir couldn't believe what was happening. The people were in shock.

Ma Barker certainly knew of the gang's activities, and she was always there to help them out before and after their crimes. Some historians doubt that she was actually a criminal and believe she was merely an accomplice. This is based on the fact that there was not even a police photograph of her before her death, and they did not have her fingerprints taken while she was alive. According to the FBI, a Tommy gun was found lying in her hands, but some

have suggested that it was placed there to justify her violent death. Many believe that the myth that Ma Barker was an evil woman was encouraged by J. Edgar Hoover.

Violent ends met the rest of Ma's boys as well. Herman Barker committed suicide during a gunfight with police. Lloyd Barker was shot and killed by his wife after being paroled from Leavenworth Prison. And Arthur Barker was killed while trying to escape from Alcatraz Prison.

The infamous Ocklawaha house was eventually repaired and re-rented. Some folks swear that Ma Barker and the boys liked that house so much that they haunt it as ghosts. It's been officially documented that this house is busy with ghostly activity. Footsteps and voices in the hallway, the sound of a card game in the living room, chips being thrown on a table and cards being shuffled can be heard throughout the house. Ma and the Gang came here to vacation, but it's like they never left.

Tourists are welcome in the little town of Ocklawaha. The people there used to do a reenactment of the event. Anyone in town can direct you to the house where Ma and the Gang are waiting for you. It is wise to respect their residence.

THE ASHLEY GANG

John Ashley and Laura Upthegrove were known as the "King and Queen of the Everglades." With a title like that,

you'd think that we would have seen a movie about these folks by now. After all, there are several about Bonnie and Clyde. The Ashley Gang were bank robbers, highwaymen, pirates and murderers and were surely just as notorious as, and even more violent than, Bonnie and Clyde.

Florida must have been a pretty wild frontier back in the early 1900s, especially down in the Everglades where folks had to rely on their ability to hunt, fish and trap just to survive. Quickness of the eye and readiness of the trigger finger were vital to existence. John Ashley learned how to shoot from his daddy, Joe, and folks say he was a definite sharpshooter. As a teenager, he spent most of his time in the Everglades gathering otter and raccoon hides for trade. Those products commanded a high dollar.

During this period, canals were being built to drain the Everglades in a big land reclamation project. One of those canals ran from Lake Okeechobee eastward toward Fort Lauderdale. It was on this canal that John Ashley began his journey down a pathway of crime, beginning with his murder of Desoto Tiger, who was the son of a prominent Seminole Indian leader. Desoto Tiger was last seen on that canal with a boat load of otter hides. An investigation revealed that John Ashley sold those hides for $1,200.

Legend claims that there was nothing attractive about Laura Upthegrove. She was a big woman with dark, unkempt hair, a tawny complexion and a generally untidy appearance. She always kept a .38-caliber pistol strapped

to her hip. John was devoted to her, and her influence over the Ashley gang was great; her commands were always obeyed. Laura's warnings had kept the gang from being busted on several occasions. She didn't make many public appearances, but when she did folks reported that they were dramatic.

Robbing banks is a crazy business. The gang thought that they had a good plot to rob the bank at Stuart, but it just didn't work according to plan. After they extracted a mere $4,500, they realized that they needed someone to drive the escape car, so they kidnapped one of the bank's customers to do the driving. That poor soul was murdered, and John Ashley was "accidentally" shot in the face by Kid Lowe, a member of his own gang. The bullet lodged in John's upper jaw, and it eventually cost him his sight in one eye. It also cost him his freedom. Needing medical attention, he was eventually captured.

John's brother, Bob, made a dramatic attempt to free John from jail. Two of the jailers were murdered outright, and Bob lost his life. John Ashley managed to beat the rap of killing Desoto Tiger, but he was sentenced to seventeen years in Raiford Prison for robbing the Stuart Bank. While in Raiford he behaved as a model prisoner and eventually make a road gang. Surely this was part of John's plan from the beginning, because he was able to escape the work gang and made his way back to south Florida, where he teamed back up with his gang, which was now into the bootlegging business. John's luck didn't hold, however. He was caught

delivering some liquor and was sent back to Raiford. While in prison, John's brothers, Ed and Frank, continued running bootleg from Bimini. One night they loaded too much liquor onto the boat and ignored heavy seas. Though friends and relatives searched the waters, Ed and Frank were never heard from again.

Leadership of the gang was taken over by Hanford Mobley. Hanford was John's sister's son who had grown up exposed to the gang's lawbreaking. He came up with the plan to rob the bank at Stuart once again. He dressed as a woman, wearing a black skirt, white blouse and a large black hat with a veil that helped obscure his features. He even wore ladies' shoes and carried a handbag. Hanford created a diversion in the lobby while the rest of the gang moved in. They ordered everyone to throw up their hands and then had the employees lie down on the floor. The gang emptied the cash drawers and got the money from the vault before escaping in a car that they had stolen. With no great getaway plan beyond that, they were eventually apprehended and thrown into jail.

Raiford Prison was not an easy place to break out of, but somehow John Ashley managed to do it again with some new gang members, all vowing never to be taken again. From this point on, the Ashley gang became even more ruthless, stealing cars, committing burglaries, hijacking bootleg expeditions and transporting liquor. After several years passed, the gang decided to rob another bank. This time they set their sights on the bank at Pompano, and

with more skill than in their previous bank robberies, they cleaned out the bank and made a good escape into their old haven, the Everglades.

Since the very beginning of the Ashley Gang's activities, there was one sheriff, Bob Baker, who was constantly on their trail. He was determined to break up the gang and bring them to justice. He and John Ashley were actually friendly to each other, and John enjoyed embarrassing the sheriff. The Ashley Gang had cost the sheriff thousands of dollars and many a sleepless night. The sheriff had experienced a number of futile shootouts with the gang.

Sheriff Baker caught the gang one night on a narrow bridge in Sebastian by boxing them in with a chain with a red lantern. The gang was heavily armed, but so were the sheriff and his deputies. When the smoke settled, John Ashley, Hanford Mobley, Ray Lynn and Bob Middleton were dead. They were buried in the Everglades.

And whatever happened to Laura Upthegrove, the confidante of John Ashley and Queen of the Everglades? She tried to commit suicide while in jail by drinking some iodine. It turned out to be a diluted solution and she suffered no ill effects. Her second attempt, some time later when she was out of jail, was with a bottle of disinfectant. She died within ten minutes. The death of the Queen of the Everglades brought a dramatic close to the tale of blazing guns, speeding bullets and the Ashley Gang.

MY FAVORITE FLORIDA STORY

Long before Ponce de Leon sailed along Florida's east coast and came ashore somewhere around Mosquito Inlet to claim Florida for Spain as La Florida—a name he chose because it was Easter, the festival of flowers—slave ships had been raiding the Florida coast, capturing friendly Indians and selling them into slavery. The world's economy was measured in slaves and gold at that time. Hundreds of complex societies of Florida's indigenous people had lived here for thousands of years in complete harmony with the land. They had come to associate those ships that came from Before the Sunrise as slave ships, and they were determined to fight viciously to their deaths against being taken as slaves. This is why so many history books portray Florida's Indians as savages. So when Ponce de Leon sailed around the peninsula to the west coast of Florida, he was met by the Calusa, who fought him from their canoes. The skies rained with their arrows, and de Leon eventually died from wounds inflicted by Calusa arrows.

The next conquistador to sail along the west coast of Florida was Panfilo Navarez, a man who earned his reputation looting and slaving in Cuba and Central America. He found that many of the Indian villages were deserted, but the skies were alive with smoke signals. He cruised alongside a beach and saw through his telescope a cane sticking up in the sand with what looked like a note attached to it. Standing next to the cane were two tall, thin

Indians motioning for Navarez to come ashore. Navarez motioned back, trying to get the Indians to come aboard. When this failed, he called for volunteers to go ashore. Only two men stepped forward. They rowed to the beach, and when they approached the cane they were quickly surrounded by many Indians. One of the men tried to run away and had his skull bashed into the sand, staining it with his blood. The other man was Juan Ortiz, and he was taken as a hostage to the Calusa village. The next morning he was dragged, naked, out onto the beach, tied to a stake and set on fire. As the flames burned his legs and sent searing pain up his back, a few more Indians arrived and put the fire out. The chief's daughter had convinced her father not to kill Juan Ortiz by suggesting that it would be prestigious to have the Spaniard as a slave. Thus, Juan Ortiz's life was spared. He became a slave and lived with the women doing mostly women's work.

Then one of the chief's sons died and was taken to the place where the Calusa interred their dead, and Juan Ortiz was chosen to stand guard over the burial site for four days. It was common amongst the Calusa to do this to keep animals from digging up remains and running off with them. Well, Juan had to sleep some time, and while he was napping an animal dragged off the chief's son. When Juan awoke and saw that the boy was missing, he followed the trail, and when he saw the brush move, he threw his spear. The boy and animal were gone. The chief was infuriated and condemned Juan Ortiz to death. But just before his

execution, a few Indians returned to the village carrying the dead boy. Then a few more Indians arrived with a dead wolf. Juan Ortiz's spear was still in the neck of the animal. Once again, the life of Juan Ortiz was spared. He was given the full rights of any other brave. Juan Ortiz lived like a Calusa and carried many of the same tattoos.

When hard times fell on the Calusa, it was customary to do a human sacrifice, and so, once again, Juan Ortiz was scheduled to die. The chief's daughter warned Juan Ortiz and helped him escape to another tribe of Indians north of the Calusahatchee. There Juan Ortiz lived amongst the palmetto until he heard that Hernando de Soto had landed off of Longboat Key. When Juan met de Soto, he could barely remember how to speak Spanish. De Soto rewarded him with a horse and a new suit of armor. However, the reward became a curse when Juan Ortiz drowned while crossing a river on horseback. He slipped from the horse, and the weight of the armor dragged him to his death.

Juan Ortiz's story was published in Portugal in 1557. It spread all over the country and created a great interest in Florida. In 1616, Captain John Smith published the story of his romantic rescue by Pocahontas. Smith's first version, published years earlier, made no mention of the Pocahontas episode. Indian historians report that Pocahontas is a nickname. Her real name was Matoaka. She would have been about ten or eleven years old at the time of the John Smith story. That she saved John Smith from being clubbed to death is all part of the white man's myth. Many historians

believe the real origin of the great American tale of the white capture, and the rescue by the Indian maiden, to be the story of Juan Ortiz.

THE NEGRO FORT

Not too long ago I was invited over to Apalachicola to perform a program of original Florida stories and songs at the Dixie Theatre. I love Apalachicola! You're not going to find a Wal-Mart there. Apalachicola is old Florida. It's all about Tupelo honey, oysters, shrimpers and other real hardworking people. It's also about that grand river whose headwaters begin way up in the Georgia mountains and travels southward as the Chattahoochee and Flint Rivers until they converge together to form the Apalachicola some 112 miles from the Gulf coast. As I looked out over the river, it spoke to me about its biodiversity and striking array of habitats. This river has experienced so much history. I asked the river if it would speak to me about the Negro fort that used to be just a little ways up the river from where I stood.

The War of 1812 was fought between the United States and the British empire. Britain was already at war with France, and in many ways the war with the United States was about trade restrictions that kept the United States from supplying France with needed supplies. Citizens of the United States were not happy that many of their sons were

being pressed into service in the Royal Navy. They were not pleased that the British were supporting and training Native Americans to help fight in the war and to prevent the expansion of a growing new country.

During the war, the British plan was to recruit the Seminole Indians as allies in the war against the states. They also created a corps of colonial marines, which consisted mostly of runaway slaves who had been trained into a fighting force. This was all done under the leadership of Lieutenant Colonel Nicholls, who was sent to the Apalachicola area for this purpose. However, the war ended before Nicholls completed his mission of training the Indians, but before he left he had built a fort on the bluffs overlooking the Apalachicola River some fifteen miles above the mouth of the river. He equipped the fort with guns, cannons and ammunition. Whoever controlled that fort would control trade on the river. When he was called back to England, he turned over control of the fort to about three hundred fugitive slaves and former members of the corps of colonial marines. There were also members of the Choctaw and Seminole nation in that mix. When word spread that there was a Negro fort, more and more fugitive slaves arrived and settled around the fort. Their numbers grew to about eight hundred.

In 1816, the United States built Fort Scott a little farther up the river to protect its southern boundary. Supplying the fort was difficult over land, so Colonel Andrew Jackson advised supplying the fort with goods moved up the

Apalachicola River. When a naval force attempted passage up the river, they were fired upon by the Negro fort, and some soldiers were killed. After that, "Old Hickory" ordered General Gaines at Fort Scott to destroy the Negro fort.

The American forces included the aid of Creek Indians who were promised that they could loot the fort if they helped with its capture. On July 27, 1816, the American forces with their Creek allies surrounded the fort and launched an all-out attack. Both sides exchanged cannon fire. The walls of the Negro fort were so thick that the fort suffered little damage. Lieutenant Colonel Clinch, in charge of the battle, had the help of two naval gunboats and decided to create a "hot shot"—a cannonball that is super heated until it glows red. It was fired over the walls and entered an opening to the fort's powder magazine, creating an explosion so horrific that it killed all but about thirty occupants. All who survived were returned to slavery. The Creek salvaged many muskets, carbines, pistols and swords, which increased their power in the region. This caused great tension between them and the Seminoles, who fought with the blacks. The Seminoles were angry with the Americans over the fort's destruction. This animosity contributed to the start of the first Seminole Indian war.

I think about the millions of gallons of river flowing by me in silence, solitude and wild grandeur, and I wonder about those poor folks who were in that fort. The river heard the explosion. So did everyone within one hundred miles. But those folks are all gone now, and only the river

lives and knows their story. They thought that fort was a blessing, but it turned out to be a curse. Due to its strategic location, the fort was eventually rebuilt as Fort Gadsden. It was occupied by Confederate troops until an outbreak of malaria forced its evacuation. After its long and tormented past, the site of the old Negro fort now lives on in peace as Fort Gadsden State Park.

WAKULLA SPRINGS

It's been nearly forty years since some dear friends drove me over to Florida's Panhandle and introduced me to Wakulla Springs. It's only about fourteen miles south of Tallahassee. As a youngster, I grew up watching Tarzan movies, and when my eyes fell upon this beautiful place I thought that I was in Africa. No wonder! They actually made a few Tarzan movies with Johnny Weissmuller here beginning in 1938.

Wakulla Springs is one of the largest and deepest freshwater springs in the world. It's filled with the purest, most beautiful water welling up out of the earth. It forms the headwaters of the Wakulla River and runs through an old-growth cypress swamp filled with lots of alligators, snakes, turtles, deer, bobcats, black bears and beautiful birds. Some say that the word was derived from the Creek Indian word "wakolla," which means loon. Others say that it comes from a Seminole Indian word that means

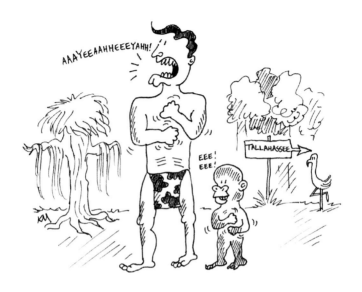

"mysterious or strange waters." Paleo Indians, who were descendants of people who crossed over to North America from eastern Asia during the Pleistocene epoch, lived at this spring. Clovis points and the remains of ice age mammals can still be found in the bottom of the spring.

I stayed in a grand, old Spanish-style lodge built by financier Ed Ball in 1937. It has about twenty-seven rooms and is decorated with beautiful marble, ceramic tiles and Pecky cypress. It's a national natural landmark and listed in the National Register of Historic Places. I was treated to some gracious southern hospitality and wonderful culinary

delights. Now, I like a good steak, but those hindquarters of a frog, dipped in egg batter and deep fried, piled high next to hush puppies and alligator nuggets will, as my Uncle Joe used to say, make you stand up and slap your mother-in-law.

There are so many stories of this place—the making of the movie *Creature from the Black Lagoon*, the Tarzan movies and the murder of "Old Joe," the 650-pound alligator that measured over eleven feet. Old Joe never bothered any man, woman or child. On a dark moonless night he was shot. But the story that I love the best was told to me by a kind old groundskeeper who kept calling the springs "Wahkoola" and not Wakulla. He was a man with a slight build and about five feet and eight inches tall. He had big hands that seemed to tell their own story of a lot of hard work. He folded them over the handle of his rake, leaned his face against his hands and told me that the springs were haunted by "little Indians" who come out late on a full moon night and play in the spring. He explained that "even though they are peaceful, you don't want to disturb them. They have bows and arrows that can go for great distances, and they are determined to protect their spring. They stay on guard until daybreak; then their chief arrives in a silver canoe and dives to the bottom of the spring and brings forth a magic plant that he uses to cure his people of their illnesses, pains and sorrows." The groundskeeper finished his story with a toothless smile. His tired eyes seemed to beg the question, "Do you believe me?" I was in a magical and wondrous place; I had no reason not to believe him. I

thanked him for his story and made my way down to the spring thinking about how our lives are made richer by chance encounters.

There are more than six hundred springs that dot the Florida landscape. They are truly natural wonders and part of the magic that is Florida. Threats to them are numerous and complex. Protecting them is everyone's job.

THE OLD MARBLE STAGE

If you were to go the Stephen Foster Memorial State Park in the beautiful little Victorian-looking town of White Springs, you would be in one of the state's most beautiful environments. The park is spread out over acres of bluffs covered with gorgeous live oaks, magnolias and pines overlooking the magical Suwannee River, a black water river lined with those trees and rocks that stretches 260 miles from the Okeefenokee Swamp to the Gulf of Mexico. It's a river that inspired Stephen Foster to write "Way Down Upon the Swanee River." The park has a magnificent carillon tower with more than ninety bells that chimes throughout the park every day. There is a folk culture center, a museum, a craft square and a gift shop. White Sulphur Spring is located within the park. It was regarded as sacred by Native Americans because the water was believed to hold special curative powers. The park offers great camping and has beautiful cabins available for rent. It has it all, with hiking

trails, picnicking, good fishing, canoeing and kayaking. It's the gateway for the Suwannee River Wilderness Trail. But if you didn't have someone point it out, you might miss the Old Marble Stage and not know its story.

The Old Marble Stage was made from marble removed from the demolition of a bank in Jacksonville, and it is the birthplace of the Florida Folk Festival, the longest continuously running folk festival in the United States. It began in 1953 and has been featuring music, food and traditional arts and crafts to highlight and celebrate Florida's many folk cultures and traditions ever since. The event is traditionally scheduled over the Memorial Day weekend. You would find the Old Marble Stage surrounded with bleachers where folks sit elbow to elbow with the crowd swaying to the sound of a song. Banjos ring and fiddles sing, and everybody knows the lyrics and has a good time all on that Old Marble Stage.

Cousin Thelma Boltin was the festival director and served as the festival's emcee for many years. I remember the Florida Folk Festival being colored with Cousin Thelma's style. It was more than just the Victorian dress and bonnet; it was like I could feel her heart beat in her performances. She made everyone feel like family. As the matriarch of the festival, she nursed its growth to more than five stages, complete with folk life demonstration areas, food booths and activity areas. She died in 1992.

In 2002, the management of the festival was transferred to the park service, and it continues to grow and thrive under

the park's direction. The Old Marble Stage is still one of the main stages. You may have missed the opportunity to see and hear folks like Diamond Teeth Mary or Fiddling Chubby Anthony, but odds are still very good that you will behold the most magnificent folk music being played in all of Florida.